IMAGES
of America

KING OF PRUSSIA

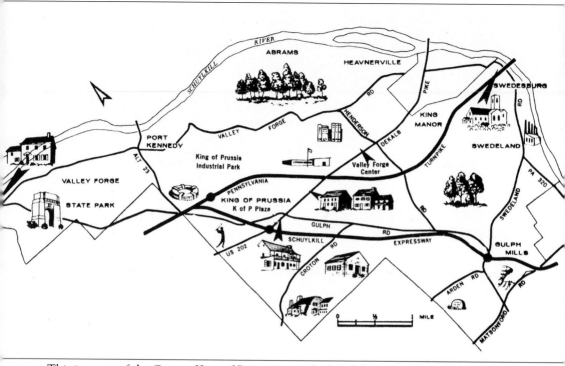

This is a map of the Greater King of Prussia area, which will be covered in this book.

IMAGES
of America

KING OF PRUSSIA

J. Michael Morrison

Published by Arcadia Publishing
Charleston SC, Chicago IL, Portsmouth NH, San Francisco CA

Printed in the United States of America

Library of Congress Catalog Card Number: 2005931161

For all general information contact Arcadia Publishing at:
Telephone 843-853-2070
Fax 843-853-0044
E-mail sales@arcadiapublishing.com
For customer service and orders:
Toll-Free 1-888-313-2665

Visit us on the Internet at http://www.arcadiapublishing.com

*Dedicated to Jean S. Olexy, my former teacher, mentor, and friend.
Thank you for your support and for making me sit up and take
notice of the world around me before it was too late to care.*

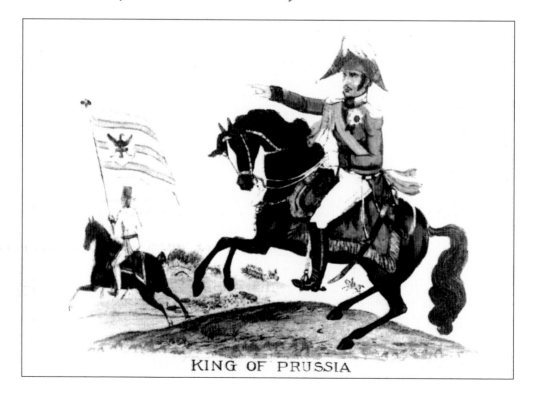

KING OF PRUSSIA

CONTENTS

FOREWORD

Foreword by Francis X. Luther, B.S., M.A., retired educator: Sitting at a table in Chili's Bar and Grill, located on U.S. Route 202 and Gulph Road in King of Prussia, one finds it difficult to imagine that this congested area was once inhabited by the Lenni Lenape Indians. Later the settlers, the Swedes and the Welsh, were living in this same area and by the early 1700s, what is now King of Prussia became a settlement originally named Reesville. The Rees's, a large Welsh family, owned most of the land in the area. Even before the American Revolution, on a tract of land about twenty miles west of Philadelphia, a small farming village was taking shape. An inn in Reesville was named the King of Prussia Inn perhaps to honor Frederick the Great of Prussia.

That was then, but this is now. The early 1940s saw the state's development of the Pennsylvania Turnpike running east and west. At the Valley Forge exit of the turnpike, in King of Prussia, the Schuylkill Expressway that ran from Philadelphia ended at the turnpike interchange. Farm lands were sold off and industrial parks, office complexes, and shopping malls were rapidly being built. Housing developments were constructed at a similar pace. Soon the quiet rural village of King of Prussia was like topsy—growing, growing, growing. It was the coming of the Pennsylvania Turnpike and the Schuylkill Expressway which aided in the development of the Greater King of Prussia area. With the intersecting of major transportation routes and the availability of land, this area of the county was destined to be a major center for economic activity. Saunders's "hamlet" of 1889 (page 12) would become the "Hub of the East."

Today, only a few percent of green space is left. Upper Merion Township is one of the Philadelphia region's premier office and retail communities and employs more people than any other municipality in Montgomery County.

Only our imaginations can capture what was once pristine land in the Greater King of Prussia area. A debt of gratitude must be extended to Michael Morrison for his efforts to preserve what exists of the old King of Prussia. Sadly, much has been lost, but Michael, through photographs and this book, will help to preserve what was and what is. As William Faulkner wrote, "Our past is not dead; it isn't even past." With this book, our past will be present and future.

INTRODUCTION

When I began putting this book together, I was motivated first and foremost by the desperate desire to raise awareness about the need for historic preservation in King of Prussia, since most of our significant early landmarks have already disappeared, and the handful that are left have a bleak future at best. I was reminded of a passage written by my grandmother, when she helped prepare a report to our township from the newly formed historical society. She said, "The importance of balance in all things is basic to the well-being and happiness of mankind. Nowhere is this fact more evident than in community planning. Therefore, it would seem apparent that an examination of our community's historic heritage should be among the first functions of any planning agency." It's almost as if we've stood idly by and allowed forceful developers to have their way with our community in the name of progress, and before long we've allowed our history to fade into distant memory. A second motivation for this book was to introduce our town to curious readers, present the many theories which attempt to explain how King of Prussia actually got its name, and allow the reader to decide which one fits best. First, I should impart some interesting facts about our town. It's the only post office of this name in the entire world, and there has never been an incorporated City of King of Prussia. The official name of the municipality is Upper Merion Township, established in 1713, and incorporated in 1789. The fire department uses King of Prussia, while the police department uses Upper Merion as their name. Over time, the geographical boundaries of King of Prussia then, have grown to be those of Upper Merion Township. Those boundaries include Valley Forge National Historic Park to the west, and the Schuylkill River to the north. So as not to cause distress to those living in neighboring towns within the confines of Upper Merion Township that might go unmentioned, I've decided to refer to the entire area as Greater King of Prussia as it has come to be known informally.

King of Prussia derived its name from a Pre-Revolutionary War inn that once stood proudly in the middle of the town. Many theories abound as to how the inn got its name. The most popular theory is that the inn was named in honor of King Frederick the Great of Prussia, for his support of the colonists during the American Revolution. Another suggests that a sign was hung outside the inn to attract the wealthy Germans who assisted Washington and his brave men at Valley Forge. A third theory tells of a surveyor who passed through town while mapping the area, and saw the sign on the inn and thought it must be the name of the town, recording it on his map. There is also a story that the proprietor of the inn needed a sign painted, and employed a German painter to do the work. After the painting of a man on horseback was finished, the German painter labeled it "King of Prussia." Finally, in Richard Affleck's work, *At the Sign of the King, Byways to the Past*, published by the Pennsylvania Historical and Museum Commission

for Pennsylvania Department of Transportation in 2002, he describes the area now known as Greater King of Prussia as being referred to as "the Sign of Charles Frederick Augustus, King of Prussia, recognizing Frederick the Great who assisted the British in defeating the French during the French and Indian War." Each theory has merit, in and of itself, and I'll leave it to the reader to decide which works best.

This then, is a look back at our town, how it has grown over the years, and how preservation should work hand in hand with development. Much of the history of our town is sketchy at best, as things have changed so very rapidly that it has been difficult to record all the facts. If I am in error with any of my findings, I will correct them in future printings. Please feel free to contact me on my website, www.historicreeseville.com should you find any errors, or just have something to add.

—J. Michael Morrison

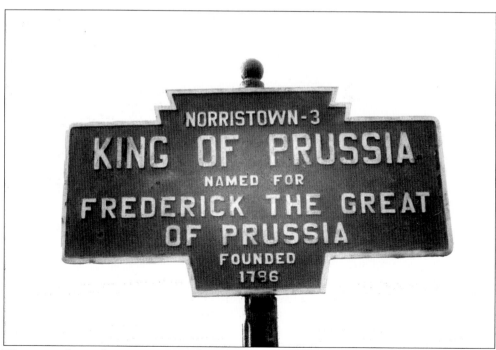

This sign welcomed visitors to town along U.S. 202 (DeKalb Pike).

One

AT THE SIGN
OF THE KING

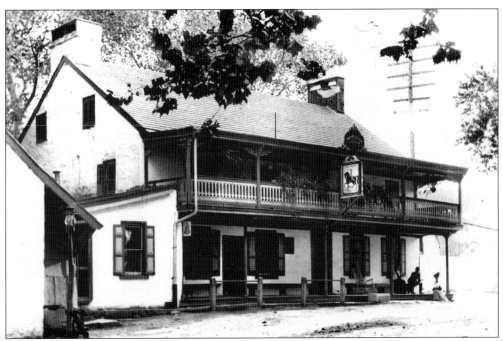

No icon better represents King of Prussia than the King of Prussia Inn as seen here in a photograph from the early-1900s. The view is west, looking down Swedesford Road (that would later become U.S. 202, DeKalb Pike). By this time the town was well established, and people all over the area used the inn as a meeting place, convenient to all. The practice was to tell someone to meet "at the sign of the King," later simplified to just "the King."

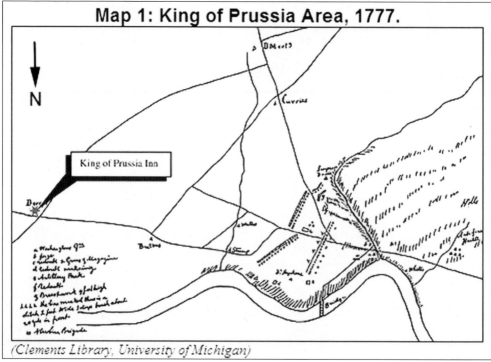

Map 1: King of Prussia Area, 1777.

N

King of Prussia Inn

(Clements Library, University of Michigan)

The University of Michigan has a wonderful prize in its archive. The Parker Spy Map, drawn in 1777 by British spy William Parker, is a detailed rendering of the area where George Washington was encamped. A portion of the map seen here includes the King of Prussia area, which was a haven for spies from both sides. The inn is referred to as "Berry's," named after the proprietor and licensee at the time, James Berry. Swedesford road (U.S. 202) is also included on the map, and dates as far back as the 1680s. (Courtesy National Park Service.)

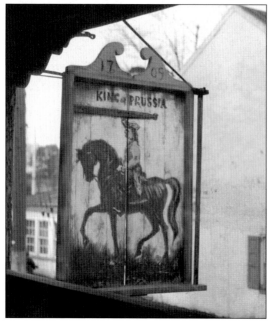

"The Sign of the King" welcomed visitors for almost 200 years, and may have been the source for the town receiving its name. Although the year 1709 is clearly written on the sign, no proof exists that there was an inn there. In addition, the image represents Frederick the Great (1712–1786), who was a powerful ruler in 1769. The sign was sold in 1920 to a resident of Philadelphia for $200, amid growing resentment towards Germany with the advent of World War I. The sign was finally recovered from an auction in 1960 by the author's grandmother, and returned to the King of Prussia Historical Society, in whose hands it is still entrusted today. (Courtesy Pennsylvania Department of Transportation.)

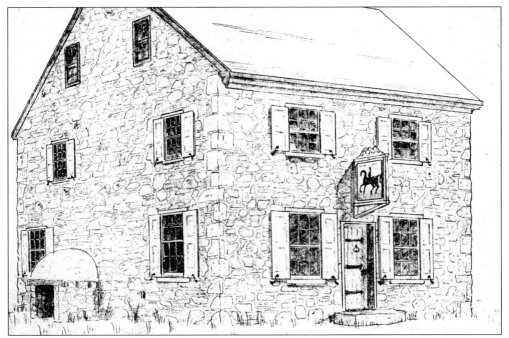

An artist's rendering from 1959 shows how the inn probably appeared in 1769, when its owner William Rees partially converted his farmhouse into a tavern, which continued as a public house through over half of the 20th-century. Records of this time period are sketchy at best. The earliest reference to the inn is a tavern license issued to Philip Rees in 1762. The earliest reference to the land appears in a deed recital "under the hands and seals of Rees Thomas and James Logan dated November 16, 1714," however, there is no evidence of a tavern existing there at that time.

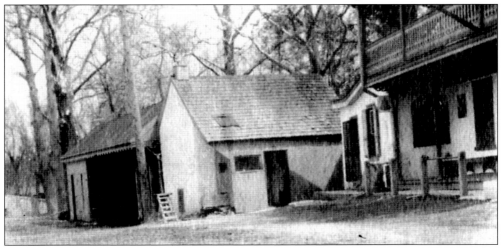

An 1893 map of Upper Merion reveals a cluster of buildings around the inn, as seen in this photograph dating from sometime between 1913 and 1930. These buildings consisted of a stable, carriage house, and storage shed. In 1902, George W. Holstein wrote of a conversation he had with Charles S. Elliott, son of John Elliott Jr., who owned the inn from 1841 to 1868. "He [C. Elliott] thought it [King of Prussia] commanded a position which should make it valuable as a business center and attractive as a place of residence." How prophetic those words would prove to be. (Courtesy Jean Wolf from the James Crosby Brown Collection.)

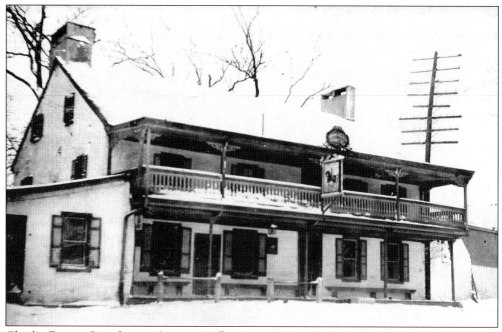

Charles Francis Saunders, in *Country Walks in 1889* wrote of the inn, "The landlady [Madeline B. Hoy], a buxom widow of 45, meets you at the door and invites you in. An old fashioned clock ticks in the hall and the floor slants invitingly to the sitting room with its low ceiling and broad window seats."

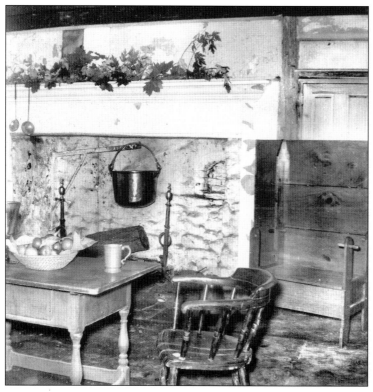

Charles Francis Saunders continues; "The meals are of the country kind-plain, well cooked and substantial and apt to terminate in three kinds of pies. If you come to supper you will probably have waffles, than which a no pleasanter fate can befall you. The kitchen which supplies the tables with the delectables referred to is one of the kind you read about-the big old fireplace and the crane and the ceiling ribbed with smoky rafters." (Courtesy Historical Society of Montgomery County.)

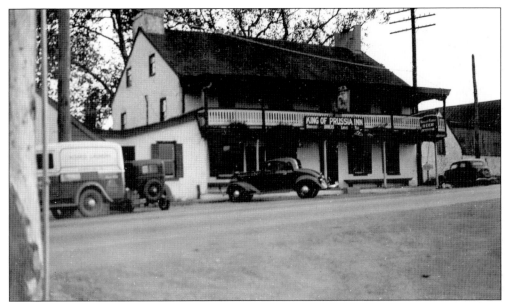

At the beginning of World War I, the inn was renamed the Old King Inn for a time, due to overwhelming anti-German sentiment. According to Sen. Philander C. Knox in a letter dated August 9, 1918, "A few patriotic citizens a few nights ago shot up the old sign-board of the King of Prussia Inn, and I believe that citizens who reside in the neighborhood are no longer registering themselves as from King of Prussia." For a short time there was even talk of changing the name of the town. In fact, a newspaper report of the time tells that "the people asked to consider the name change of King of Prussia because of the resemblance of the name to that of a recent warring country and to change the name to Port Kennedy (a close neighbor), which is more suitable."

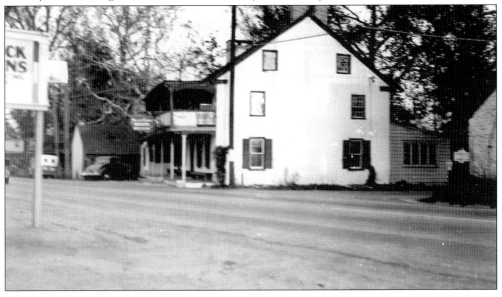

From the Kitchen of: King of Prussia Inn

PEAR HONEY

4 pounds of Kieffer Pears and 4 pounds of sugar, simmered together for one hour

Cook 3 lemon rinds until soft, cut fine and add to pears along with the juice of the lemons.

Add ¼ lb. Finely cut preserved or crystallized ginger to above

Boil gently for 1 hour. Makes about 15 pts.

In 1920, Anna Heist Waters purchased the inn with her husband Thomas and operated it for the next 32 years. These are copies of two of Anna Waters's favorite recipes for peaches. During Prohibition, only a restaurant could be conducted at the inn, with the specialty of the house being beefsteaks, later called steak sandwiches, served open faced over bread with a delicious mushroom sauce. With the repeal of Prohibition in 1933, the bar was reopened and a new house specialty, the mint julep, became quite popular, served by a stately gentleman known only as Williams. At least two guidebooks of the era mention the inn as a worthwhile stop. Many notables also visited the inn during its lifetime. Bob Hope was said to have dined there, as well as Sen. Barry Goldwater. Local advice at the time reported that for anyone looking for his doctor should "call the K of P Inn, he'll be there."

From the Kitchen of: King of Prussia Inn

PEAR PRESERVES

Take large perfect pears, half-them, and remove seeds being careful to retain stems

Cook in small amount of water until fairly soft

Lift out carefully and put on large platter

Fill cavity with candied cherries, pineapple, orange, and lemon peel cut fine, along with blanched almonds

Put halves together and tie securely

Measure water-add cup for cup of sugar

Bring to boil, add pears and cook for 10 minutes

Seal in hot jars

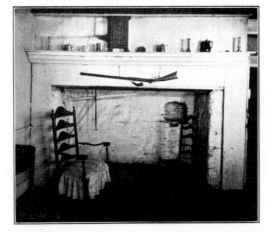
An advertisement for the King of Prussia Inn from the early 20th-century states that "Washington and his officers more than once held Masonic Lodge" at the inn. It has even been speculated that General Lafayette was inducted into the Masons there. It is also known that Jefferson, Madison, and Monroe took refuge there to escape the yellow fever epidemic of 1793. (Courtesy Vincent Martino Jr.)

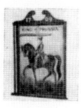
In 1952, the Pennsylvania Highway Department made plans to change U.S. 202 from a two lane macadam road to a four lane divided highway from Norristown to West Chester. The plan also called for the demolition of the inn. Anna Waters, determined to keep her business going, decided to move to another location. She found the perfect place in Jeffersonville, but poor health forced her to close less than 10 years later.

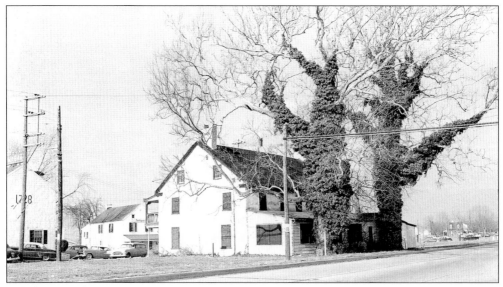

By 1953, condemnation of the inn was completed and the Pennsylvania Department of Transportation purchased it for $139,000. In 1955, a group of local citizens headed by local pediatrician Dr. Robert May formed the Committee to Save the Inn, shortly thereafter known as the King of Prussia Historical Society. They convinced PennDOT to reroute the highway and save the inn, unfortunately, marooning the once magnificent hostelry on an isolated island of concrete. This picture from 1955 shows the inn looking north and east on U.S. 202. Now the inn, deserted and unreachable, fell into disrepair and became the object of vandalism.

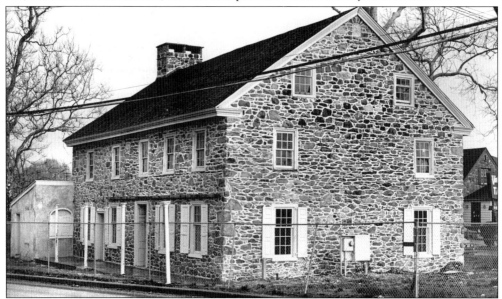

In 1960, the inn was registered with the Historic American Building Survey, and in 1967, Jack Shain raised $800 for repairs, but after some work was completed, funds ran out and an electrical fire in the basement caused extensive damage, stopping work altogether. Panic set in through the community with the approach of 1976 and the nation's Bicentennial. Local businessmen helped the effort by contributing to the revitalization of the inn, and it is said that it was the repointing of the stone with portland cement that held the building together for another 25 years.

The King of Prussia Inn is seen isolated between two lanes of U.S. 202 in this photograph from the late 1960s. Notice how close the southbound lane of the highway came to the front door, rendering access impossible. Many plans to use the site for historical and educational purposes were conceived and soon abandoned as impractical. Furthermore, the need for additional highway expansion made it necessary to again contemplate the permanent removal of the building.

On Sunday, August 20, 2000, the King of Prussia Inn, a 580 ton structure, was finally moved to its new home one-half-mile away to the east, as seen in this photograph taken on moving day. Under the watchful eye of the chamber of commerce, contributions from local businesses and interested residents as well as federal, state, and local governments, made it possible to save this landmark structure, after sitting idle for over 50 years. New regulations put in place in the late 20th-century provide for more careful planning to stay away from historic structures completely. (Courtesy Vincent Martino Jr.)

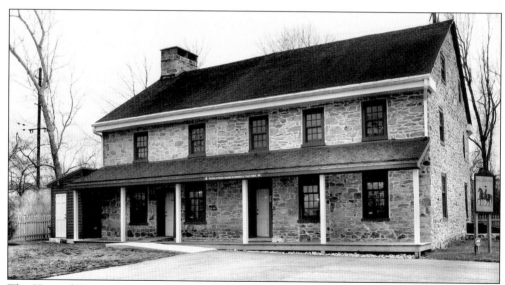

The King of Prussia Inn now resides at 101 Bill Smith Boulevard, as seen in this photograph taken in the spring of 2005. The building is now used as offices and is the headquarters for the Greater Valley Forge Chamber of Commerce and the King of Prussia Historical Society, which share its ownership. This is not the end of the story of the story of a building that is almost 300 years old, but a new beginning for the inn and for the community, past, present, and future.

Two

RECONSTRUCTING OUR TOWN

(1878–1940)

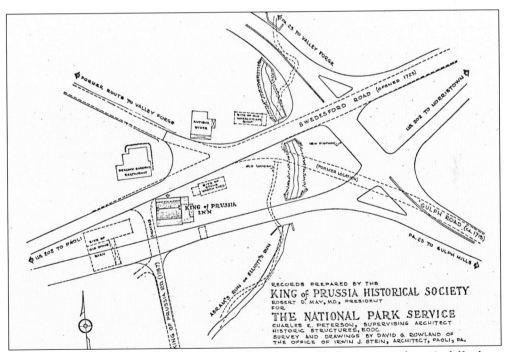

King of Prussia has changed so completely from its humble beginnings that it's difficult to imagine exactly how it was originally laid out. With the help of this map from 1959, one can begin to see not only how the town took shape, but how it began to evolve. It was a busy intersection, with travelers passing on their way to Norristown from the Port of Wilmington, with cargo to be loaded on barges for the trip to Philadelphia. The town was also about a days ride from Philadelphia and would often be a perfect resting place for travelers who were heading west to Ohio. (Courtesy King of Prussia Historical Society.)

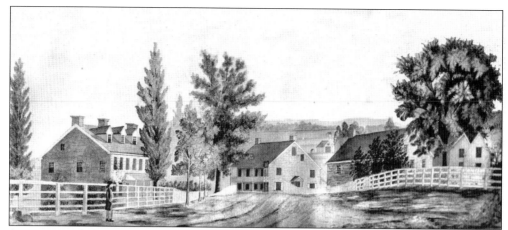

A painting titled *View of Village of King of Prussia* by A. Mies of Philadelphia, dates from between 1803 to 1830. Some artistic license may have been taken by the artist, but for the most part this is probably how the town appeared to a traveler arriving from Valley Forge. The King of Prussia Inn can be seen in the foreground, and is a very good representation of how it probably appeared. (Courtesy King of Prussia Historical Society.)

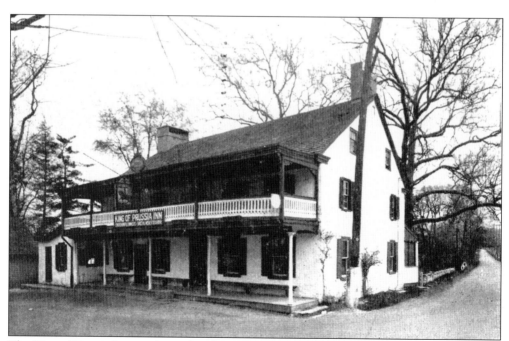

The King of Prussia Inn was located at the crossroads of Swedesford Road (U.S. 202) and Gulph Road. In this postcard from the 1930s, King of Prussia Road (then called Wayne Road) can clearly be seen to the right of the building. There is still visible evidence of this portion of King of Prussia Road, located right next to the Honda motorcycle shop and Motel 6, on U.S. 202 north.

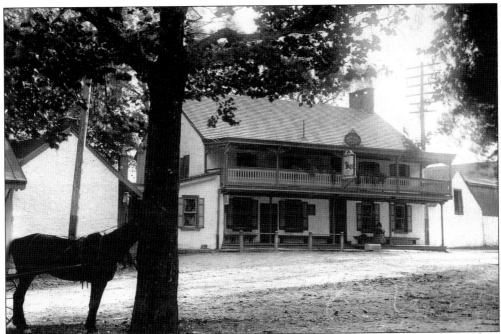

A view of the King of Prussia Inn taken around the beginning of the 19th century shows an area in the foreground that was used for hitching teams of horses. This triangular area would become the subject of litigation in 1935 when the owners of the Peacock Gardens tried to prevent a filling station from being built. Also, you will notice several other buildings, including an old stone barn in the background on the right, and a wagon shed on the left. (Courtesy Historical Society of Montgomery County.)

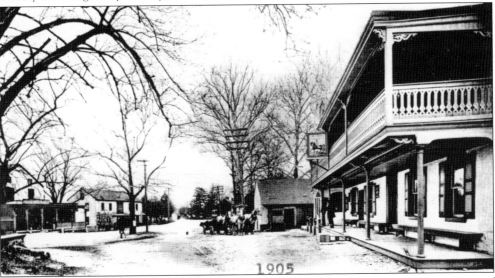

This postcard view of the town was taken in 1905 from Swedesford Road at the intersection of Wayne Road, looking northeast at what is now U.S. 202. Absolutely nothing remains of this view today, except perhaps, the approximate direction of the road. Many of the early buildings in this chapter can be seen together in this photograph that was made for a postcard, which makes it one of the most important images that remain of our town. (Courtesy Ed Dybicz.)

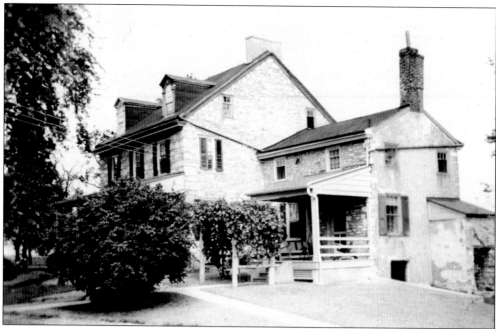

Originally constructed in 1747 by Henry Griffith, this building is one of the oldest in town and the only one that still remains in its original location. It was the home of Dr. Henry DeWitt Pauling, a prominent physician who came to town in 1835, and it remained in his family until the beginning of the 19th century. The location was perfect for a restaurant, so the doctor's home began to evolve. (Courtesy King of Prussia Historical Society.)

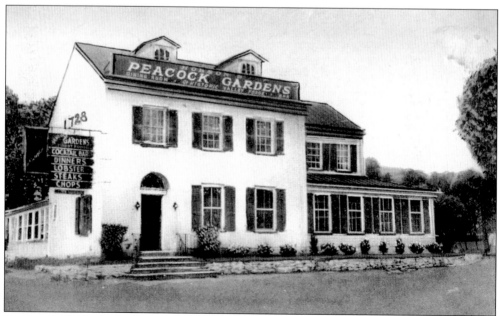

By the mid-1920s, the building located at 826 West DeKalb Pike had become a restaurant called the Peacock Gardens, as seen in this early postcard. There was a lovely garden in the back complete with live peacocks living in the trees, where patrons could dine alfresco.

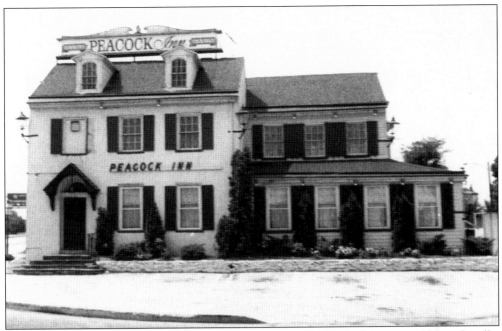

By the early-1970s, the ownership of the business had changed, as had its name. Although still a popular dining spot for locals, it had lost much of the magic it had during its golden years. The building itself began to look tired and in need of a facelift. (Courtesy Upper Merion Township Public Library.)

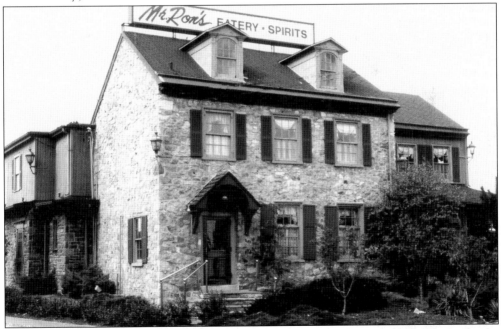

The mid-1970s brought about big changes. The building was restored to probably its most authentic original condition, as Mr. Ron's Eatery took over, and enjoyed great success for over 10 years. Pizzeria Uno became the owner in the late 1980s, and today it is Kildare's. After its most recent renovation only two of the original walls remain. (Courtesy King of Prussia Historical Society.)

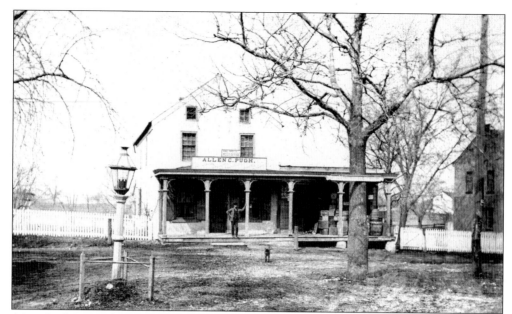

An early photograph shows Allen Pugh on the porch of his post office and general store, located at the intersection of what was then Swedesford Road (U.S. 202 or DeKalb Pike) and Gulph Road. The photograph was taken on April 17, 1878, the day Pugh took up residence here after being appointed postmaster on April 3 by David M. Key, postmaster general to the U.S. Grant. The photograph was probably taken from the porch of the King of Prussia Inn across the street.

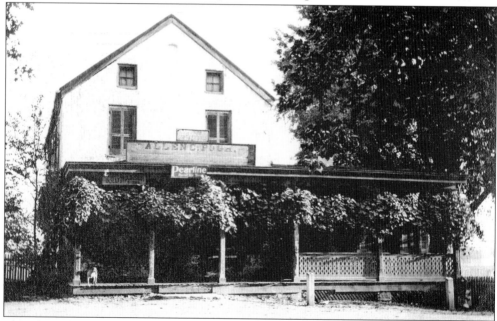

This photograph was taken around 1933, shortly before Pugh retired. He served as postmaster of King of Prussia for over 55 years. He would walk down Wayne Road and meet the Chester Valley train to receive the mail. In later years, he would need a wheelbarrow to collect the ever increasing amount of mail for this now thriving community. Notice how the signage remained virtually unchanged in over 50 years.

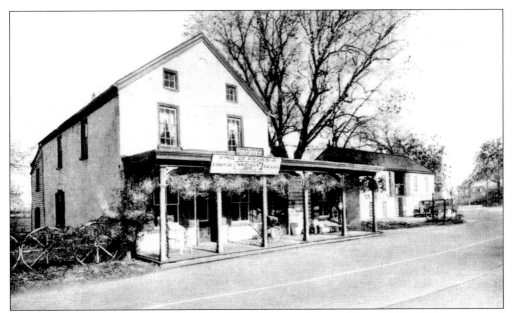

This postcard from the mid-1930s shows the King of Prussia Antique Shop and Post Office, converted from a general store when Allen Pugh retired and sold the building. The author's grandmother, Lucressa Morrison, ran it for over 30 years and also served as postmistress. Behind and to the right of the building is the annex, which once housed a wheelwright shop and a blacksmith.

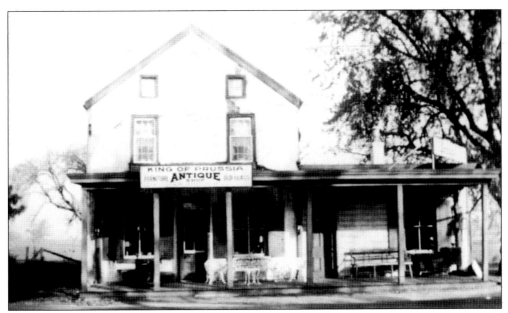

In this photograph from the late-1930s, even more changes to the building are evident. The intersection of Swedesford Road and Gulph Road had become a hub of activity, and businesses flourished. (Courtesy Upper Merion Township Archive.)

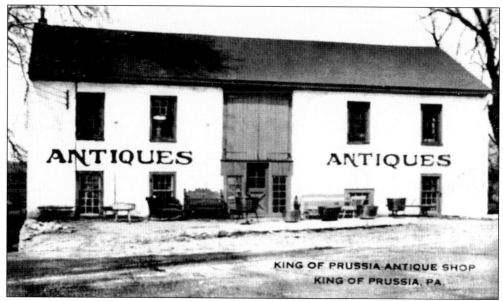

A second postcard from the late-1930s shows a better view of Lucressa Morrison's annex. This building was located on the south side of Route 202, where a Lukoil gas station stands today. Notice the antiques outside on display that were only put away in bad weather and never disappeared due to theft.

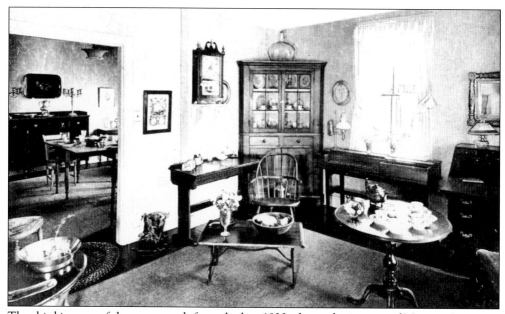

The third in a set of three postcards from the late-1930s shows the interior of Morrison's antique shop, located at 812 West DeKalb Pike. Here one could browse the rooms and select from some of the finest early-American furniture and glass. The back of this postcard emphasizes "NO REPRODUCTIONS." Morrison retired in the mid-1960s, but the business continued to flourish until the late-1970s when the building was sold to Mobil Oil Corporation and soon after destroyed.

Three

OUR TOWN EVOLVES
(1940–1975)

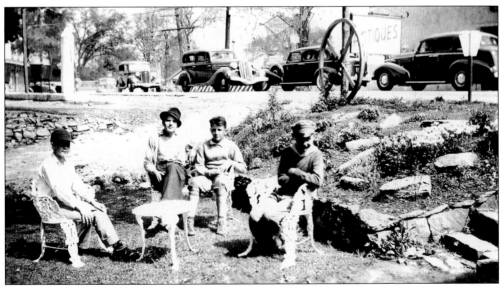

Four young men pose for a picture in the late-1930s at what has already become the busy intersection we know as DeKalb Pike (U.S. 202) and Gulph Road (then Route 23). The intersection will soon be reconfigured and the roads widened to allow for better traffic flow. Since buildings were originally built close to the road, and the roads were only about as wide as two wagons, widening them to accommodate automobiles would forever change the town. The author's uncle, Robert L. Morrison, is seated on the far right, and the author's father, James W. Morrison, is seated next to him.

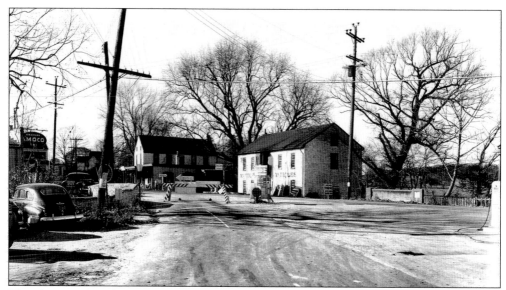

This photograph, taken in 1951, looking northwest from Gulph Road is a good example of how King of Prussia was evolving. Notice the three filling stations, Esso and Amoco on the left, and Atlantic on the right. Also, in the foreground off to the right is a sign directing traffic to the westbound turnpike. The road detour may have been the result of widening the intersection, or the construction of yet another major roadway, the Schuylkill Expressway, which linked the Pennsylvania Turnpike with Philadelphia, and helped jumpstart growth in the area.

A similar view from the same era, taken from a little farther south on Gulph Road, shows the King of Prussia Driving Range and the Woodshed that once stood where the Howard Johnson's Motor Lodge was located, and where Best Western is located today. The Wood's moved their business to Ridge Pike when the Pennsylvania Turnpike and Schuylkill Expressway connected in 1952 and are still in business today. Notice the sign by the road on the right, advertising gasoline for 22.9¢ per gallon. (Courtesy Cummins family.)

KING OF PRUSSIA FOOD SHOP

KING of PRUSSIA, PA.

Four miles south of Valley Forge at the junction of routes 23 and 122

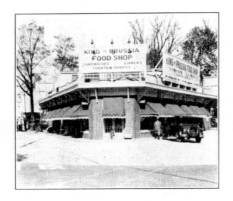

Good Food –

moderately priced –

amid pleasant

surroundings

Ample
parking space

Specializing in

Chicken and Waffle

Duck and Steak

Dinners

Hot & Cold Platters

Also a la carte service

SANDWICHES ∴ ICE CREAM ∴ FOUNTAIN SERVICE

An advertisement from 1932 shows the King of Prussia Food Shop, later owned by Ed Mack, located at the intersection of DeKalb Pike and Gulph Road, near the site of Chili's restaurant (formerly Bob's Big Boy and Howard Johnson's Restaurant). It appears that there's a typo in the advertisement, as no reference to Route 122 has ever been found. (Courtesy Vincent Martino Jr.)

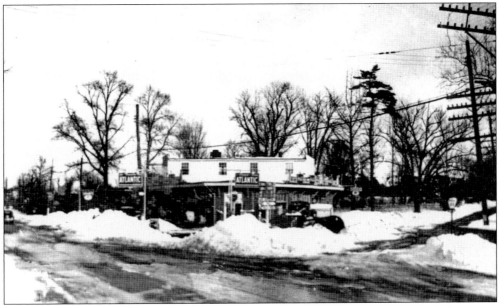

A later photograph of Ed Mack's, probably taken in the mid- to late-1940s, shows some interesting changes to the façade, but the property remained virtually the same. Mr. Mack was known for holding off local police and highway authorities with a shotgun, when his building was to be torn down in 1952 to allow for the road to be widened. Only a phone call from the governor and a check in hand for the fair market value of the property would allow for construction to begin. (Courtesy Cummins family.)

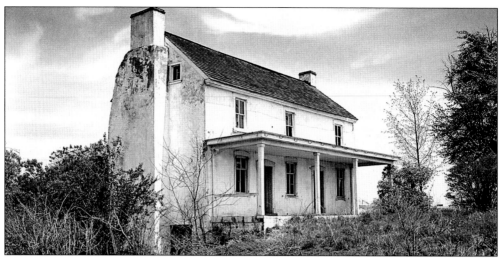

The Pechin Farm House is thought to have played a part in sheltering, feeding, and caring for troops encamped at Valley Forge in 1777–1778. Pennsylvanians are often amusingly resistant to the fact that their history antedates the American Revolution by 100 years. Yet architectural historians have been turning up evidence of substantial building in Eastern Pennsylvania dating as early as 1633. The Pechin House would appear to be one of these very early dwellings, although the exact date of construction is not known. The chimney on the west end of the structure testified to its antiquity, but oddly the house shows signs of both the Swedish and the Welsh types of construction. It is known that Edward Thomas, a Welshman, owned the land in 1685, but like so many other old properties in King of Prussia, it doesn't necessarily mean that there was a house on it at that time. The earliest recorded deed dates back to 1790, when James Aiken owned this home. It was located on North Gulph Road, directly adjacent to the Pennsylvania Turnpike Toll Plaza and sadly was demolished by the Pennsylvania Traffic Commission (PTC) in the 1960s.

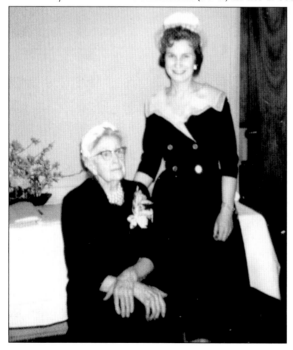

Ann W. Pechin (left) seen here with Ruth Jelinek in a photograph from the 1960s, was probably one of the last persons to live in the farmhouse. She began her teaching at Roberts School in September of 1895, and would ride to school each day in her buggy. Pechin was also a member of the school board, and was president in 1937. She was also a motivating force as a member of the League of Women Voters. In the early 1960s, from the eloquent pen of Pechin, came *Pechin's New Third Eclectic Reader*, filled with fascinating reflections of her days as an educator in King of Prussia. Only a handful of copies exist today, and the author is hopeful that it will be reprinted.

A photograph from the 1940s shows the Stewart Fund Hall, which was built in 1879 and located at the intersection of U.S. 202 and Allendale Road where a bank now stands. It was left as a legacy for educational purposes by William Stewart, who died in 1808. The building served as a public library, a meeting house for the grange, a literary society, a building and loan association, as well as a place for students' final exams before they were promoted. It also served as a police station, a church, and the King of Prussia Fire Company was organized there in a public meeting in 1950. Unfortunately, the building gave way to progress in 1970. (Courtesy Upper Merion Township Public Library.)

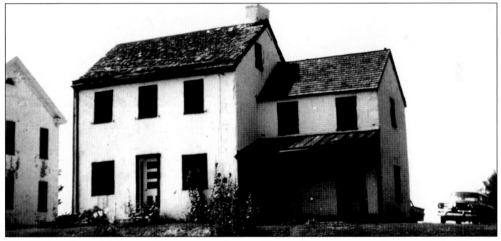

The Union School Masters Quarters was located just adjacent and to the east of the Stewart Fund Hall. The original Union School was situated in "Matthew Roberts's wood" in 1740. It was a log school, subsequently destroyed and replaced by a stone structure in the late 18th century. In 1810, the Union School Masters Quarters were constructed probably to avoid the necessity of farming him out to various homes. In 1836, an addition was added to the south end to serve as added space for the school. In 1878, the original stone Union School building was obliterated and the Stewart Fund Hall was erected on its foundation. The School Masters Quarters was also destroyed in the late 1960s. (Courtesy Upper Merion Historical Society.)

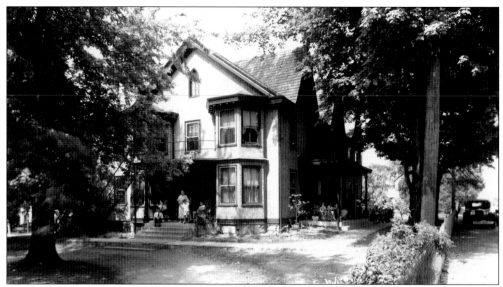

This farmhouse was one of the original seven buildings in King of Prussia. In October 1922, Jesse Royer-Greaves purchased it from William West, and moved her Royer-Greaves School for Blind from Strafford into this more spacious facility. It was the first of only three schools in the world created to teach blind children who had additional challenges. This photograph was taken in 1929, and the view is northeast, looking up DeKalb Pike at what was later to become U.S. 202. This school too was outgrown, and in 1941 was moved to its current location in Paoli. The late Jean Supplee then purchased the property, turning it into a boarding house. (Courtesy Royer-Greaves School for Blind.)

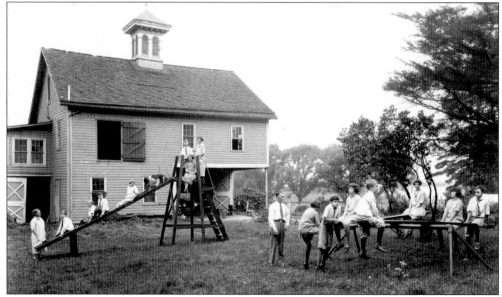

This photograph from 1927 shows some children enjoying outdoor activities at the Royer-Greaves School for Blind. According to a newspaper article from 1991, there were 27 students at most, who were taught sewing, cooking, weaving, basket making, leather, woodwork, knitting, and other vocations. This view looks directly north; at what is now the Court and Plaza at King of Prussia. (Courtesy Royer-Greaves School for Blind.)

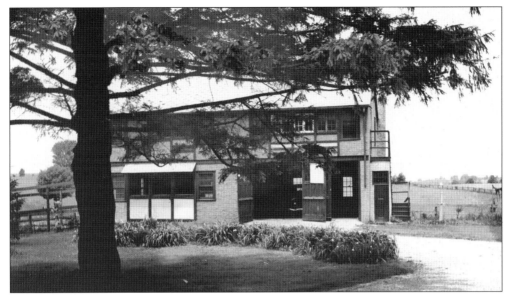

An outbuilding on the property of the Royer-Greaves School for Blind has had many lives. Originally built as a carriage house, it became a handy garage and caretaker's quarters as seen in this photograph from 1926. It later housed the first fire truck for the newly formed King of Prussia Fire Company in 1950. In its final years it served as a Pepperidge Farm Thrift Store, as well as other manifestations. Directly across Route 202 from Chili's, it is now part of the parking lot for the mall. (Courtesy Royer-Greaves School for Blind.)

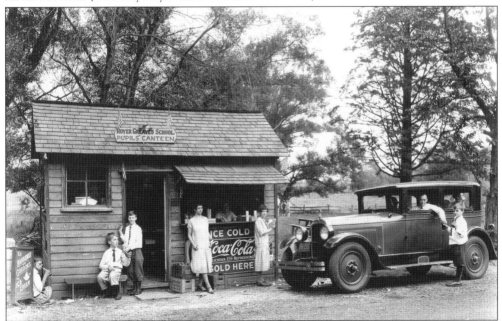

The Pupil's Canteen was a refreshing oasis on DeKalb Pike in 1926. Here students from the Royer-Greaves School sold food and drink to weary travelers. Speculation is that this stand was located just northeast of the school, and later served as a post office, after a few minor modifications. The entire property was demolished in November of 1991. (Courtesy Royer-Greaves School for Blind.)

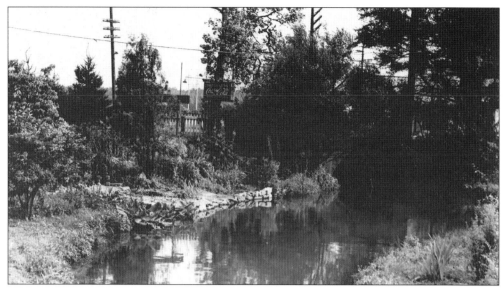

This bucolic setting reveals the meandering stream known as Abram's Run, looking southeast from the Royer-Greaves School property. A Coca-Cola sign is visible in the distance, probably from Ed Mack's. If one were standing in the same location today, they would be standing in the parking lot of the King of Prussia Plaza, as the stream was covered over in the 1991 renovation. (Courtesy Royer-Greaves School for Blind.)

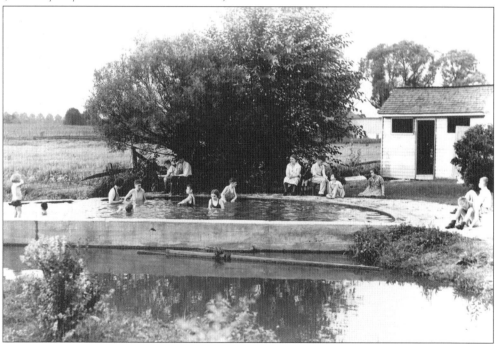

A look in the opposite direction from the photograph above shows a group of children cooling off in a pool on a hot afternoon at the Royer-Greaves School. The pool was fed from the stream, as the children enjoyed a bit of relief from the summer sunshine. It is hard to imagine one of the largest shopping complexes in the world replacing this tranquil scene. (Courtesy Royer-Greaves School for Blind.)

Here is another view of the Royer-Greaves School for Blind, looking north and east. The lovely front lawn would slowly disappear as U.S. 202 out front was widened, until 1991 when the building itself had to be taken. At the time of its destruction, one could not step off the front porch without stepping directly into traffic. In fact, the entrance had to be moved to the side of the structure to allow for safe egress. The building was eventually torn down on November 20, 1991, to make room for more parking at the mall. (Courtesy Royer-Greaves School for Blind.)

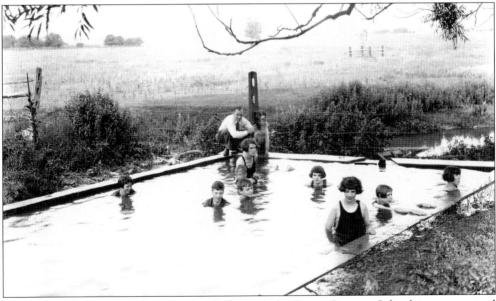

The tranquil pasture in this photograph behind the Royer-Greaves School is a very good reference as to how King of Prussia appeared in 1927. Notice the farmland stretching as far as the eye can see. This area behind the school was once part of Wilson's Dairy, and off in the distance is Allendale Road, and the land that the Valley Forge Drive-In Theatre once occupied. Costco is now located on that property. (Courtesy Royer-Greaves School for Blind.)

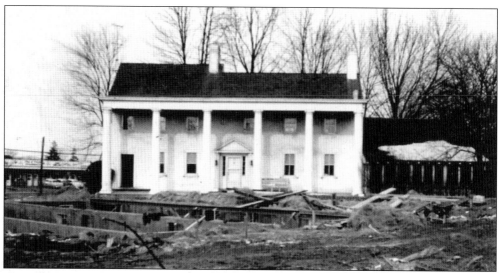

The Crockett House is seen here, in a photograph from 1956, shortly before it was torn down to make way for a Howard Johnson's Restaurant and parking lot. Today, Chili's and Wawa occupy the ground at the intersection of U.S. 202 and Gulph Road. The home was built in 1750, and like many others in the area exhibited characteristics of both Welsh and Swedish Architecture. The John A. Crockett family occupied the home for 36 years and also owned the land across Gulph Road where the driving range stood. Crockett once owned the King of Prussia Inn and served as tax collector for 20 years. (Courtesy Upper Merion Township Public Library.)

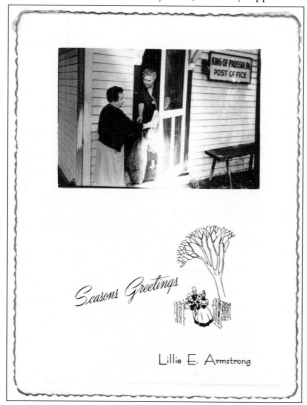

The King of Prussia Post Office had many incarnations in the early days. This Holiday Card shows what is believed to be its second location, just north of the former Royer-Greaves School in what was once the Pupil's Canteen. Lillian Armstrong is seen here handing out mail to Jean Supplee, who owned the property. Both Armstrong and Supplee served as postmistresses in the early days, after Allen Pugh, his daughter Mary, and Lucressa Morrison retired from service. (Courtesy Bob Lee.)

36

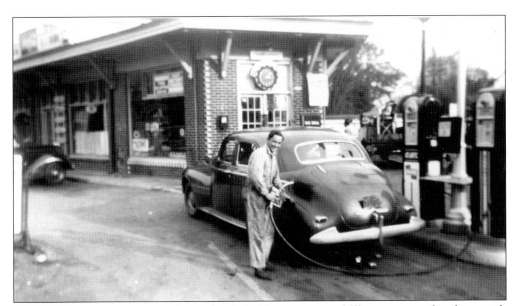

Art Cummins is seen hard at work outside Ed Mack's restaurant and filling station in this photograph from the late 1940s, located just across the road from the Royer-Greaves School and the post office. All work was done outside where the lift was located. (Courtesy Cummins family.)

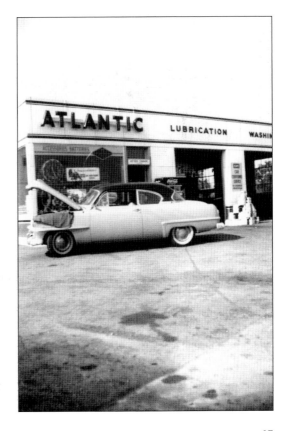

The continued growth of King of Prussia in the 1940s and 1950s brought about the need for additional retail space. Art Cummins built a modern service station, as seen here in this photograph from the mid-1950s. This station was located where Buckman's Ski Shop now stands, from 1955 to 1961. The Cummins family still operates an automotive maintenance and car rental business in town today. (Courtesy Bob Lee.)

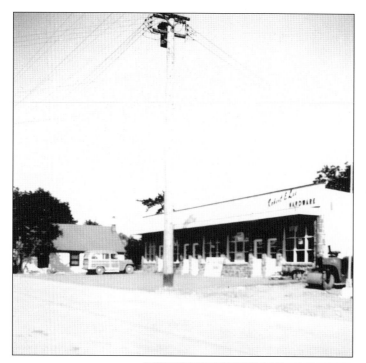

In 1954, a group of enterprising merchants created King of Prussia's first strip shopping center in a building erected by Domenic Pasquale. It consisted of Robert E. Lee Hardware, Morris Weisbaum's drug store and soda fountain, Eddie Knasiak's barber shop, Joseph's Hair Styling, and William E. Wills Real Estate. (Courtesy Bob Lee.)

Eddie Knasiak is seen here in a photograph from the early 1950s. There wasn't a kid in town that didn't get his haircuts at Eddie's Barber Shop. Eddie moved his business to the Village Mart in 1964 when Domenic Pasquale developed another retail property on Shoemaker Lane. (Courtesy Bob Lee.)

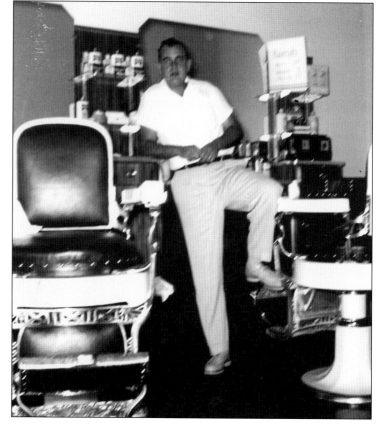

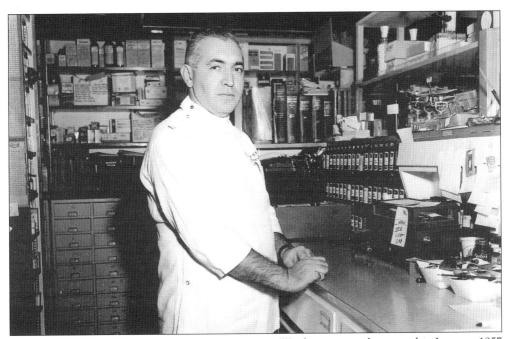

Another merchant in the strip center was Morris Weisbaum, seen here in this January 1957 photograph. Weisbaum's drug store was the place to go for a great Breyers Ice Cream Sundae at the adjoining soda fountain, after a haircut at Eddie's. (Courtesy Herb Weisbaum.)

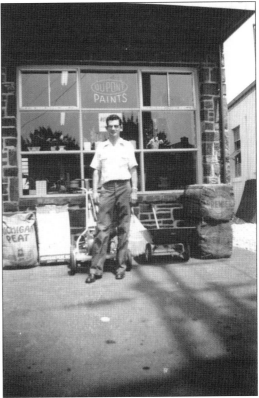

Rounding out the crew of merchants from the first strip center in King of Prussia is Robert E. Lee, seen here in a photograph from 1954. His hardware store was the only one in town, and extremely complete. It was mind boggling how Lee always had what a customer needed, and knew where everything was kept. Robert E. Lee also moved his business to the Village Mart in 1964 where he remained in business until he retired in 1979. The business was sold to Chuck and Jane Montague, who continued to operate it for many years. (Courtesy Bob Lee.)

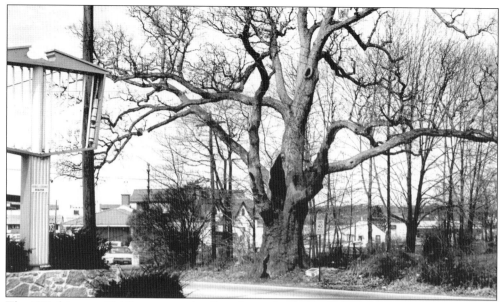

The "Washington Oak" once stood tall and proud just east of the intersection of U.S. 202 and Gulph Road. The small plaque visible at the base reads: "White Oak-Quercus Alba-circumference 18'6" at 4.5" above ground in 1932-growing here more than 100 years before William Penn's arrival in 1682-Washington and his army marched by it to Valley Forge in 1777." In the background, Howard Johnson's Restaurant, Jean Supplee's, Penney's and John Wanamaker are visible. (Courtesy King of Prussia Historical Society.)

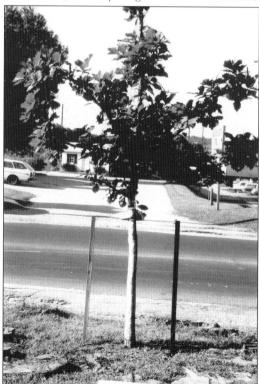

All good things must come to an apparent end, as we see in this later photograph of the Washington Oak, which was removed to allow for more parking at Wawa. The new tree, another White Oak, vanished mysteriously one evening prior to yet another widening of the parking lot. But the plaque was saved, and now hangs in the office of the director of public works at the Upper Merion Township Building. (Courtesy King of Prussia Historical Society.)

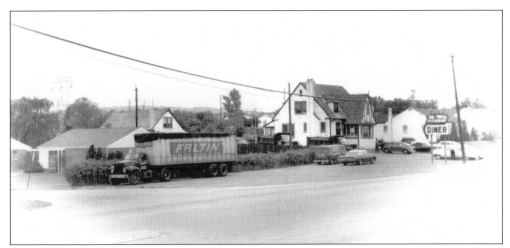

The Valley Forge Restaurant once occupied the property at the intersection of U.S. 202 and Allendale Road, across from the Stewart Fund Hall and Union School, where the former McDonalds now awaits resale. Valley Forge Homes can be seen in the background, and the character of the automobiles in the parking lot probably dates this photograph to the early 1960s. (Courtesy Upper Merion Police Department.)

This is a photograph of the Eckman home, which was reached by continuing north on U.S. 202 to the intersection of Henderson Road. This photograph was taken in 1961 just hours before the Eckman home was razed. A Commerce Bank now occupies this land the Eckman's once called home. (Courtesy Eckman family.)

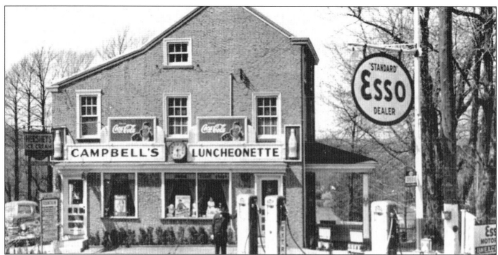

Campbell's Luncheonette was located at the intersection of Henderson Road and Montgomery Avenue (now Gulph Road). In this photograph from 1943, we see a thriving business catering to the traffic on the road to Philadelphia, and hungry students from the high school across the road. (Courtesy Emma Carson.)

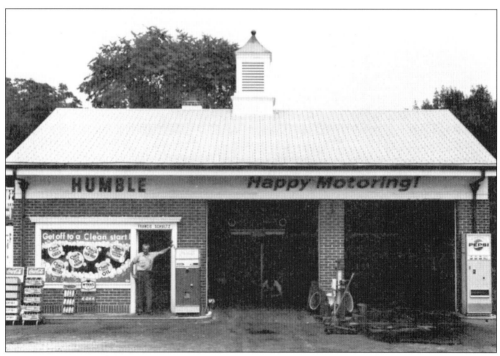

With the advent of the Schuylkill Expressway and the closing of the high school, Campbell's was replaced by Franny's Exxon, as seen in this photograph from 1970. Francis Schultz can be seen in the doorway of his full service station, where gasoline would be pumped, windshields would be cleaned, tires would be checked for proper pressure, and all with a friendly smile. Gone are the days of the service station and gasoline that sold for under 40¢ a gallon. (Courtesy Chamber of Commerce.)

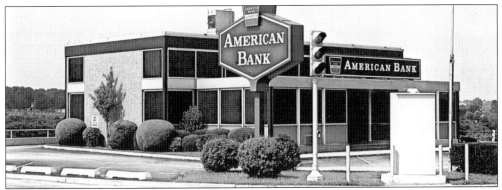

American Bank was located at the intersection of Goddard Boulevard (now Mall Boulevard) and U.S. 202. The bank was first built as the People's National Bank and Trust Company of Norristown, with American Bank being its second incarnation, as seen here in this photograph from 1970. The bank later became Meridian, Core States, First Union, and is now Wachovia. This building is one of the few that remains in nearly original condition. (Courtesy Chamber of Commerce.)

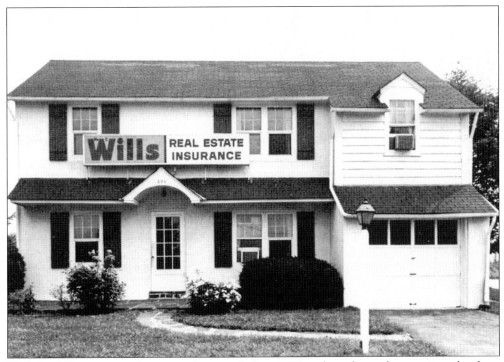

Wills Real Estate is seen here in a photograph from 1970 and was located approximately where the Lone Star sits today. It sat directly across the street from the Washington Oak on Gulph Road. William E. Wills was also the tax collector, taking over from John A. Crockett upon his retirement in 1933. (Courtesy Chamber of Commerce.)

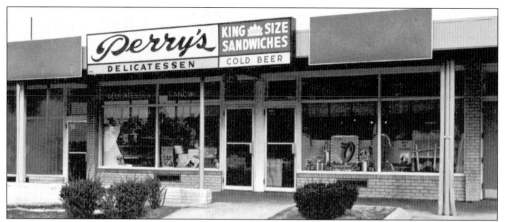

Prior to the development of the Court and Plaza at King of Prussia, the Valley Forge Shopping Center was the place to shop. Located along U.S. 202 between Town Center and Henderson Roads, in the Red Hill section of town, it contained an A&P, W. T. Grant, Valley Forge Drug Store, Donutland, King Theatre, Valley Forge Lanes, and so on. It also featured the best deli in town. Perry's made the perfect sandwich, always served with a huge pickle. Michael's Deli now occupies the space as the tradition continues. (Courtesy Chamber of Commerce.)

If one were to travel toward the Schuylkill River to the Abrams section of town on Henderson Road in 1970, they would have surely passed this small strip center at the intersection of Beidler Road. Genuardi's grocery store soon moved in next door, and folks who lived in the area were now able to shop closer to home. The center is still in existence today, although the businesses have changed. (Courtesy Chamber of Commerce.)

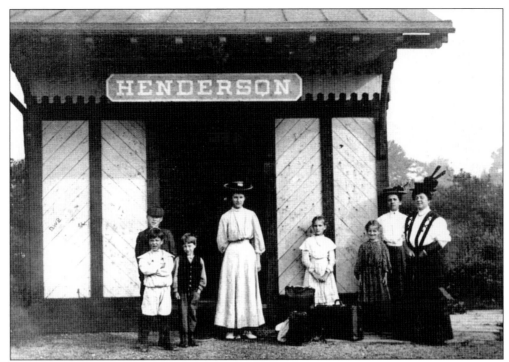

The Levering family poses for this photograph while waiting for the train at Henderson Station. The station was served by the Chester Valley Line and was located on Henderson Road near Church Road. In fact, that part of town was known as Henderson Station for many years. Built in 1850, this was the same rail line that brought mail to the residents of King of Prussia once a week. The line was abandoned years ago, but the right-of-way is now being developed into a multi-use trail. (Courtesy Emma Levering.)

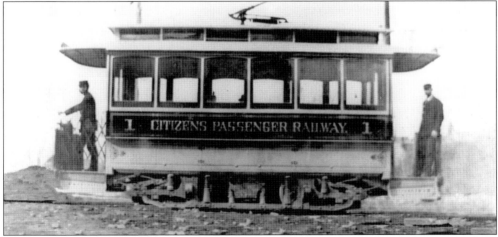

Trolley cars were also used to carry passengers throughout the area as electric power supplanted horses on the Norristown Line. This photograph from 1893 shows the motorman in the exposed front, and the conductor in the back. This line extended from Norristown via the DeKalb Street Bridge, to Bridgeport, east on Fourth Street to Coates Street, to Swedesburg along River Road, into Swedeland, where it terminated near the blast furnaces at Alan Wood Steel Company. The fare was 6¢. These trolleys were eventually replaced in 1933 by buses. (Courtesy Ed Dybicz.)

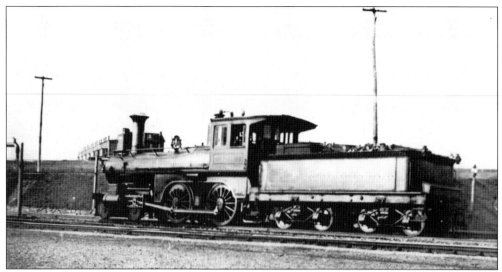

A steam engine is seen on the Reading Line at Abrams Station in this photograph from 1920. The Reading had two different freight lines that led to a connection with the Baltimore and Ohio in South Philadelphia. One line came down from New York through Trenton, New Jersey, while the other followed the Schuylkill River to Reading. Its primary purpose was to carry anthracite coal to Philadelphia. (Courtesy Ed Dybicz.)

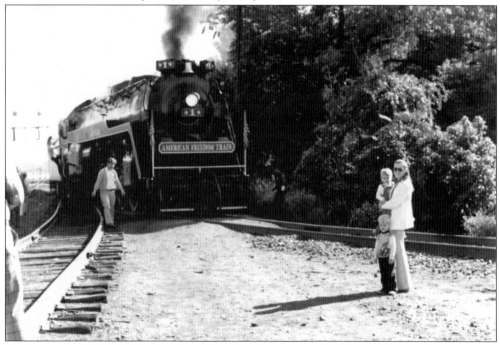

On September 12, 1976, the American Freedom Train arrived in King of Prussia from its cross-country journey, and was switched at Abrams Yard to an industrial siding near the old Sears warehouse on Valley Forge Road, where it remained until September 14. The 25 car train featuring many wonderful artifacts from our nation's past was pulled by an old Reading T-1 engine that was salvaged from a Baltimore scrap yard. Here we see the Keenan family as they welcome the train to the area. (Courtesy Bill Keenan)

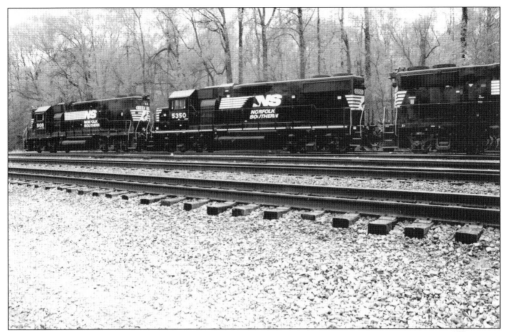

The Reading Line built many rail yards along its route. Just west of Bridgeport is the point where passenger trains crossed the river and joined the freight main line heading for Reading. The junction was called Norris, and just west of that was Abrams Yard. Many inner city yards were abandoned, making Abrams a significant classification yard along the original Philadelphia and Reading main line. Although most coal transportation had ceased by 1970, a good bit is still carried to the old Pennsylvania Railroad ore yards in South Philadelphia. Today, the Abrams yard continues to be a very busy place as evidenced by these photographs taken in the spring of 2005. The yard has always been a gathering place for train watchers due to the many different locomotives present.

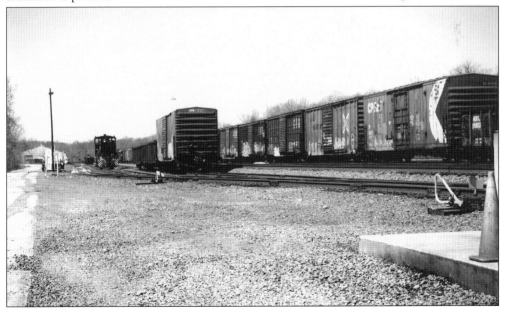

Maplecroft Dairy Farm was located along Gulph Road, on the land where the King of Prussia Plaza sits today. They also had a dairy bar, located at the intersection of Gulph Road and County Line Road. It was known as the Betsy Ross, later to be reincarnated into the Sting, Baron's Inn, and now Creeds. The Wilson family ran the farm for many years, and their home is pictured below. To get a perspective, the roof of this farmhouse can be seen in the photograph on page 28, just to the left of the nearest telephone pole. The land stretched behind the Royer-Greaves School, all the way to Allendale Road, where it abutted the Anderson Farm. The Clyde Beatty and Cole Brothers Circus would set up their tents on that land in the late 1950s, and the entire town would turn out to witness the spectacle. Bill Wilson opened a real estate office in the family home, as seen in the photograph below taken in 1970. The farm name was sold, and moved to Phoenixville, and the farmhouse (below) has now become an outdoor furniture store. (Courtesy Chamber of Commerce.)

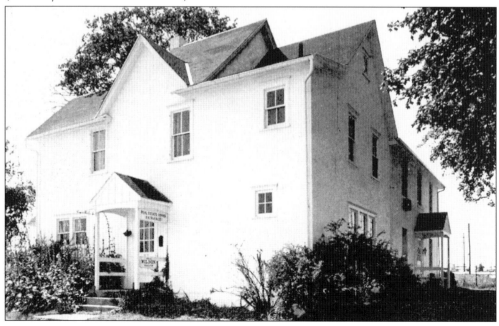

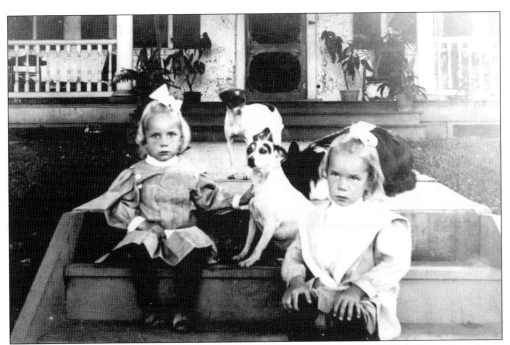

These early photographs, probably from 1910 to 1920, were taken on the Wilson Farm. Seen here, from left to right in both photographs, are Thomas and Robert Smith, sons of Robert John Smith who worked on the farm. As was the turn of the century custom, the little boys were dressed as girls. The photograph below shows the boys have matured and are dressed more appropriately as they play in the farmyard with their goat cart. The Smith's lived in a tenant house on the farm, and the children of the families often interacted. (Courtesy Emma Levering.)

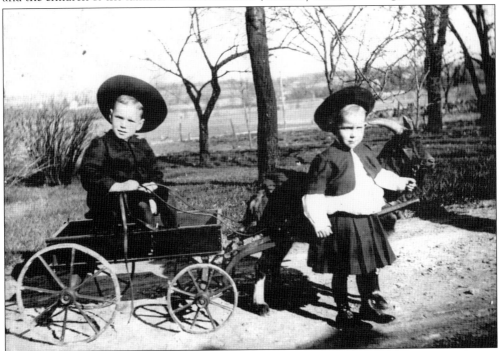

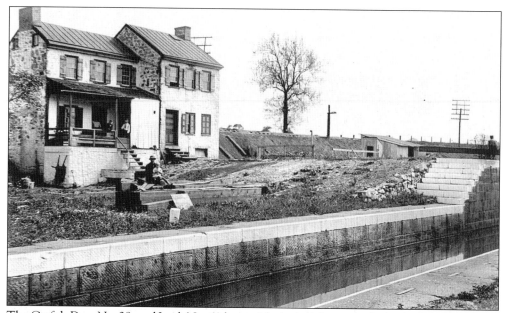

The Catfish Dam No. 28, and Lock No. 63 here with the lock house in the background, was once situated on an eight acre tract of land near Port Kennedy. It was part of the Schuylkill Canal System, which began operating in 1824. Two masted schooners would travel to Port Kennedy to load lime. Their masts were hinged at the base, which enable them to be lowered to the deck as they passed under the canal bridges and also served as derricks for loading cargo. The lock house was destroyed by fire in the 1970s, but the lock still remains visible today. (Courtesy Upper Merion Township Public Library.)

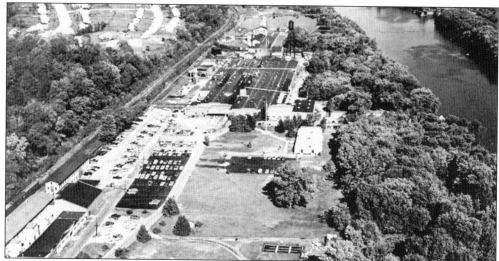

Synthane Taylor Corporation, shown here in 1970, was one of the leading businesses in western Port Kennedy. Originally, the property belonged to the Kennedy family, and "Kenhurst" thrived as a busy river port. It was later the site of Siegmund Lubin's Betzwood Motion Picture Studio, which began in 1913. It was one of the largest studios in the country and the first producer to mass market movies to the public. The village Port Kennedy was often turned into a western town or Civil War set for the filming of motion pictures featuring Hollywood's top movie stars. The property is now being refurbished for residential use. (Courtesy Chamber of Commerce.)

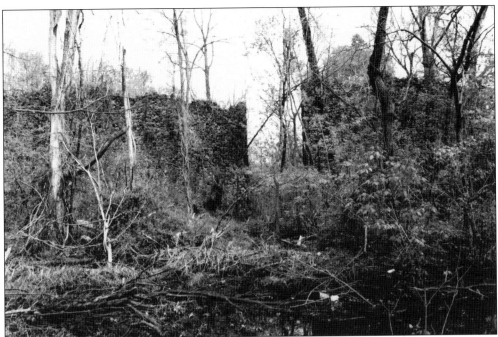

Huge icehouses along the Schuylkill River in the Abrams section of King of Prussia provided jobs for hundreds in the wintertime. The river was shallow, and the ice could be cut, pulled ashore, and stored in the vast facilities. The Knickerbocker Ice Company was the largest in the area. Knickerbocker employed 400–500 men in one facility, cutting and transporting ice whenever its thickness reached six inches or more. In the winter of 1899, over 2,000 carloads of ice were shipped to Philadelphia and beyond. On November 27, 1894, one of the larger icehouses caught fire and burned to the ground. One of the stone walls of that building can be seen in the picture above taken in the spring of 2005. The building measures about 30 feet by 60 feet. The photograph below, taken in Swedesburg in February of 1918, shows the ice on the Schuylkill. The advent of refrigeration put an end to the ice cutting industry. (Courtesy Ed Dybicz.)

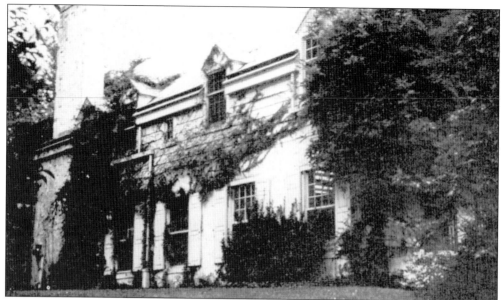

"Winter Camp" and the former Upper Merion Cultural Center is seen here in this photograph from 1970 (above), and more recently from the spring of 2005 (below). It was built in 1810, and the 1932 and 1946 additions were probably designed by noted architect R. Brognard Okie. A log home once stood adjacent to the existing structure and served as the quarters for Gen. John Peter Muhlenberg while the American Army was encamped at Valley Forge, during the winter of 1777–1778. John Moore, for whom the home was named, died in 1778, soon after the Continental Army settled in, and the home was inhabited by his wife Jane. Muhlenberg became a distinguished soldier and statesman, as well as a popular clergyman in the Lutheran and Episcopal Churches. This building is owned by Upper Merion Township, and although stabilized, is in need of extensive work in order to be maintained. It is hopeful that it may someday serve as a local history museum and learning center. (Courtesy Chamber of Commerce.)

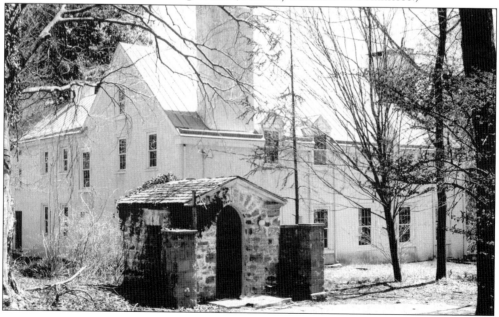

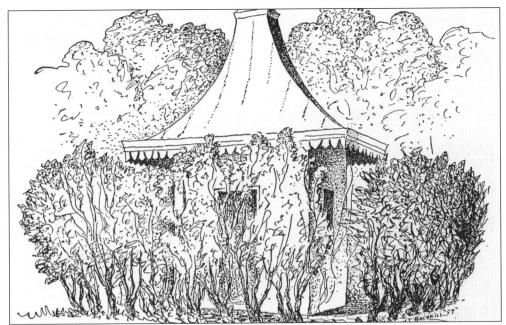

Once standing on the property was a very unusual outhouse. It was built in 1860 and is of Chinese Victorian design. The author could only find a sketch of the building in tact, which is shown above, as included in a report to Upper Merion Township from the King of Prussia Historical Society in 1959. Shortly after the report, as seen in the photograph below, the outhouse was dismantled for "storage and re-erection" by the historical society at a later date, due to "the uniqueness of the architectural detail and the importance of its historical association to its owner." Unfortunately however, the whereabouts of the structure is unknown at this time. (Courtesy Upper Merion Township Public Library.)

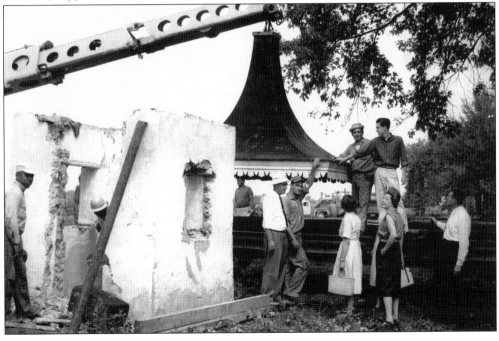

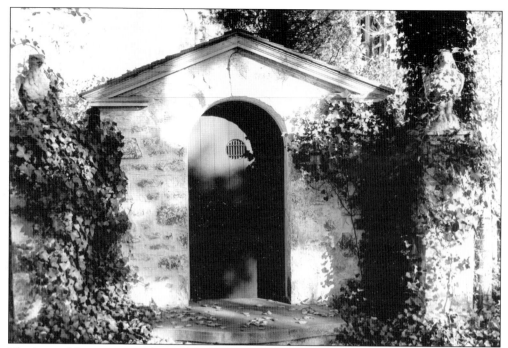

The beautiful entrance to the Muhlenberg Quarters is seen here in this photograph from the early 1970s. The property is located on Moore Road, between Valley Forge Road and First Avenue. Moore Road is one of the oldest roads in the township, and once connected directly to Gulph Road in the vicinity of the Pennsylvania Turnpike Interchange. (Courtesy Upper Merion Township Public Library.)

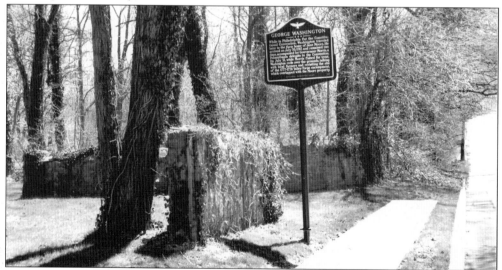

The entrance to the Muhlenberg Quarters is seen here on Moore Road, revealing a portion of its obvious splendor. The road sign reads, "While in Philadelphia for the Constitutional Convention, Washington traveled here to the farm home of Jane Moore. He arrived on July 30, 1787, and remained two days, accompanied by Governor Morris, a Pa. delegate to the Convention. While Morris fished for trout, Washington rode over the grounds, talking with local farmers and revisiting the site of the 1777–1778 encampment, which overlapped the property."

Four

THE HUB OF THE EAST

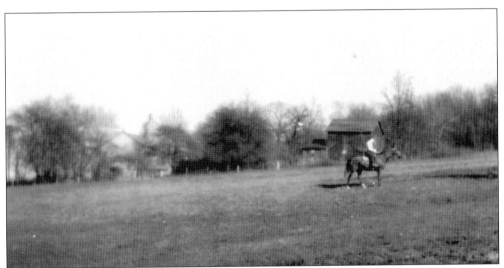

Since its beginning, King of Prussia has been a central hub for transportation, with the strategic intersection of Swedesford Road (later U.S. 202) that linked Wilmington, Delaware, with New York, and Gulph Road, which was the most direct route to Philadelphia and the best road to Valley Forge and Reading. Over the past century it has changed from a mostly rural community to a semi-metropolis, due in large to these two roads. In this photograph from 1942, Emma Lew Levering is seen riding her horse on land that will soon become the Schuylkill Expressway. (Courtesy Emma Carson.)

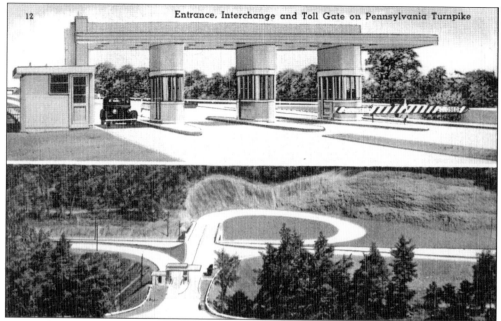

Entrance, Interchange and Toll Gate on Pennsylvania Turnpike

Oddly enough, the Pennsylvania Turnpike, "America's First Superhighway," had its beginnings as a railroad, when William H. Vanderbilt attempted to devise a route that would link Harrisburg with Pittsburg, in direct competition with the Pennsylvania Railroad. His attempt failed, but the right-of-way proved useful in establishing what we now know as the first highway system without traffic lights, railroad crossings, or driveways. On November 15, 1950, the second leg, known as the Philadelphia Extension, was opened to traffic linking Harrisburg with Valley Forge the eastern terminus, which actually ended in King of Prussia. The postcard above represents a typical interchange, built in the 1940s. The hexagonal design allowed for greater visibility, and was adopted by many other highway systems. Below is a postcard of a typical rest stop on the turnpike, which was operated by Howard Johnson's and Gulf Oil. There are two rest stops in the greater King of Prussia area, still serving both the eastbound and westbound directions.

Restaurant

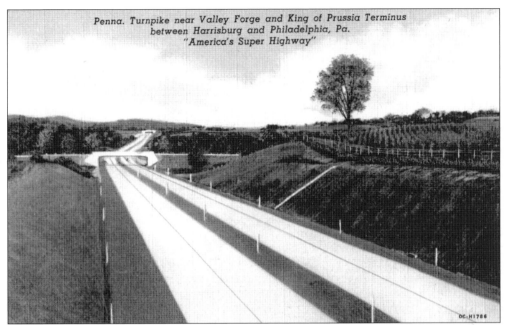

Penna. Turnpike near Valley Forge and King of Prussia Terminus
between Harrisburg and Philadelphia, Pa.
"America's Super Highway"

Another wonderful image of the early days of the Pennsylvania Turnpike is shown here in this postcard from the 1950s. Notice the straight stretch of roadway designed for speeds of 100 miles per hour, where motorists could enjoy a minimum of 600 feet of visibility ahead. Also, the roadway was constructed on southern exposures whenever possible, to take advantage of sunlight heating the roadway, to help eliminate ice and snow.

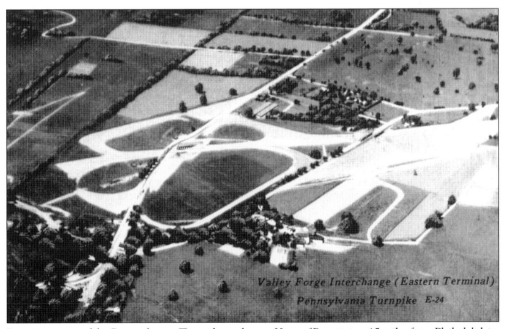

Valley Forge Interchange (Eastern Terminal)
Pennsylvania Turnpike E-24

In anticipation of the Pennsylvania Turnpike ending in King of Prussia just 15 miles from Philadelphia, work began on the Schuylkill Expressway in 1948, to link center city with the newly proposed super highway. A postcard from that era shows an aerial view of the area under construction.

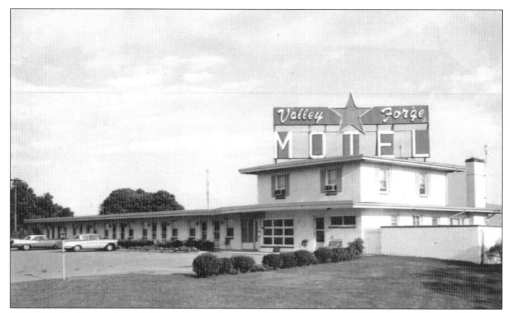

By 1950, the Pennsylvania Turnpike ran between Harrisburg and Valley Forge/King of Prussia, and a bridge over the Susquehanna River would soon extend the highway all the way to Pittsburg. Visitors from the west soon arrived in droves, making Valley Forge/King of Prussia a popular tourist destination. Motels sprang up along the route, carrying the Valley Forge name as far west as Downington. Today, the turnpike covers over 514 miles, carrying 156.2 million vehicles a year.

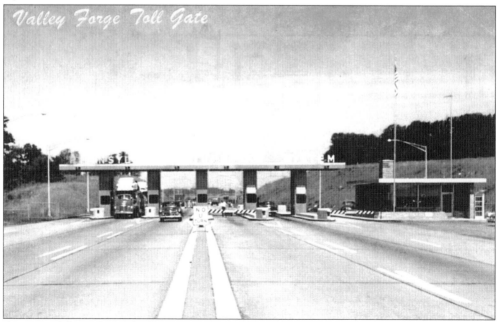

A postcard from the early days of the Pennsylvania Turnpike shows the entrance to the toll plaza at Valley Forge, looking north. Notice the hill to the right that will become the future home of the General Electric Space Center, which is now Lockheed Martin. (Courtesy Vincent Martino Jr.)

The Levering farm on Gulph Road is pictured here looking north toward King of Prussia. A portion of this land in the foreground would be taken for the construction of the Schuylkill Expressway (Interstate 76). Kingswood Apartments would be built on the hill in the distance, around 1964, as King of Prussia welcomed an era of unprecedented growth due largely in part to highway expansion. (Courtesy Emma Levering.)

This photograph from 1970 was taken from a vehicle just beginning the journey from King of Prussia to Philadelphia via the Schuylkill Expressway (Interstate 76). This 25 mile highway follows the contour of the Schuylkill River, on a borrowed design from the Valley Forge Parkway of the 1930s. This controlled access highway linked the city with the greater King of Prussia area, and soon people who worked in the city were able to commute from the suburbs in a reasonable amount of time. (Courtesy Chamber of Commerce.)

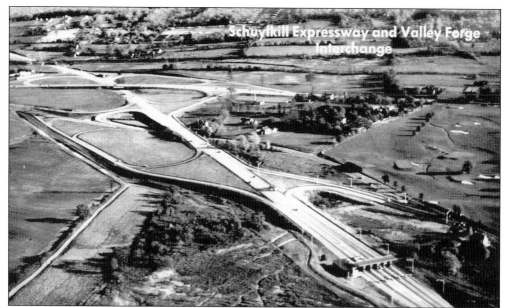

Schuylkill Expressway and Valley Forge Interchange

An early 1960s postcard provides an aerial view of the completed Pennsylvania Turnpike and its seamless transition with the Schuylkill Expressway as part of Interstate 76. This connection would forever alter the complexion of the area, as King of Prussia would quickly become a destination to live, work, and shop. Notice the open space surrounding the highway that would soon give way to development all in the name of progress.

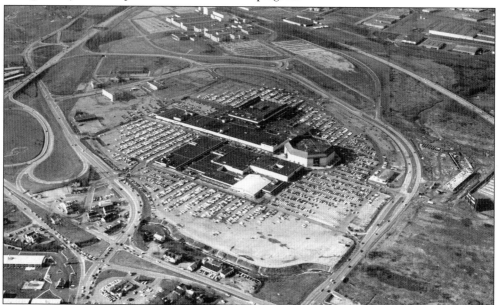

The completion of major arteries to the area ushered in an era of expansion and population growth as farmland rapidly gave way to development. In this aerial view of King of Prussia taken in 1970, the primary roadways can all be seen, with the Pennsylvania Turnpike in the background, the Schuylkill Expressway to the left, and the old intersection of Swedesford Road (U.S. 202) and Gulph Road in the foreground. Many of the old buildings from the original town can still be seen prior to demolition or relocation. (Courtesy Kravco Simon Company)

Five

THE COURT AND PLAZA

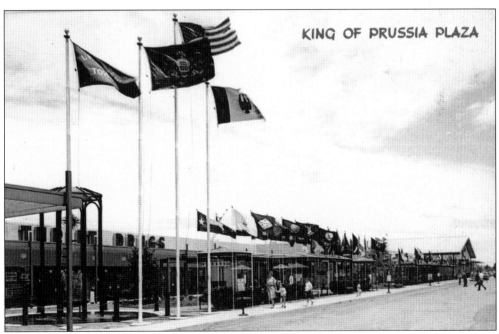

With the rapid increase in population, King of Prussia began to expand its retail market. In the early 1960s, the M. A. Kravitz Company began its $20 million effort to create the world's largest shopping center. This postcard shows how visitors were welcomed by these flags flying proudly. (Courtesy Willie Fogle.)

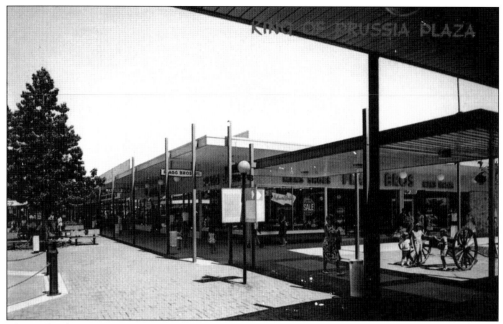

The early Plaza consisted of 1.3 million square feet of retail space, as E. J. Korvette's (1962), J. C. Penney (1963), John Wanamaker (1965), and Gimbel's (1966) eagerly took space. These anchor stores were soon joined by banks, shoe stores, restaurants, a grocery store (Acme), and numerous specialty shops. This was still an outdoor mall, and many local residents have fond memories of shopping there in the early years, with the sounds of chimes from the clock tower and the leaves swishing by and collecting outside the stores in fall. (Courtesy Chamber of Commerce.)

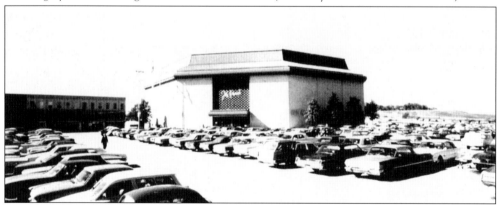

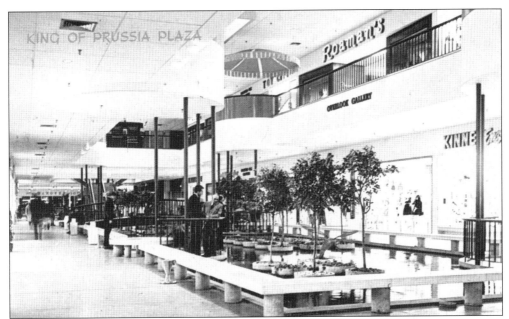

Another postcard above and a photograph below, both from 1970, show the further expansion of the King of Prussia Plaza (by now referred to as "the Mall"), as indoor shopping was added. This addition brought many more shoppers to the area and business thrived even in bad weather. Soon all the major manufacturers were represented and one could find just about anything there. The first interior stores were set in an area known as the Picadilly Arcade, but would later be renamed the Continental Arcade, due to its close proximity to Valley Forge Park. (Top postcard courtesy Willie Fogle; bottom photograph courtesy Chamber of Commerce.)

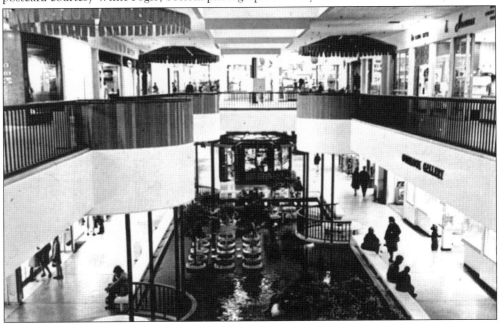

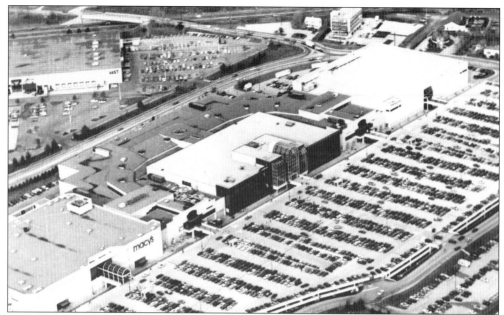

In 1979, approval was granted for further expansion, and the $25 million dollar Court at King of Prussia was born. This aerial view from the 1980s shows the plan of the newly expanded shopping mall, as upscale stores such as Bamberger's, Bloomingdale's, Abraham and Strauss, and Macy's were added to the mix. (Courtesy Kravco Simon.)

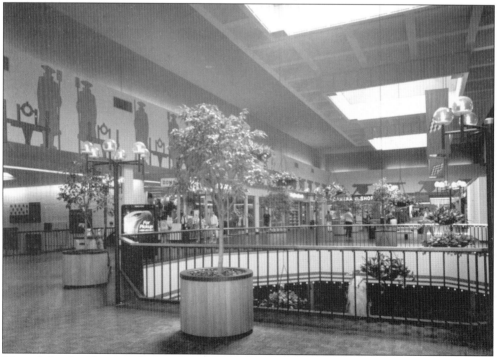

Meanwhile, the Plaza was becoming quite dated, as seen in this photograph. In the mid-1990s, work began on an aggressive renovation in order to bring it back to its original splendor. Relocation of J. C. Penney's allowed for the creation of a new bi-level space. (Courtesy Kravco Simon.)

This artist's rendering takes the space in the photograph on page 64 at the bottom, and transforms it into a new center court. (Courtesy Kravco Simon.)

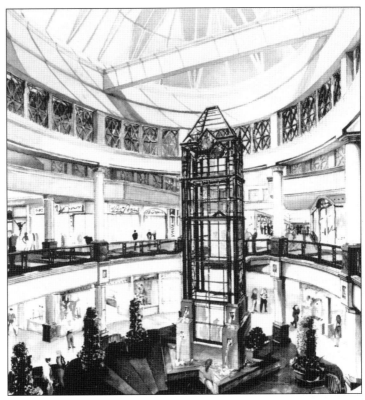

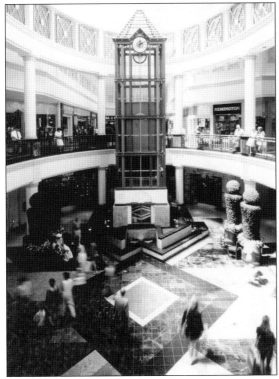

Here we see the finished product, as the space has been changed according to the artist's plan. In this photograph, vast open areas coexist nicely with intimate low ceilings. (Courtesy Kravco Simon.)

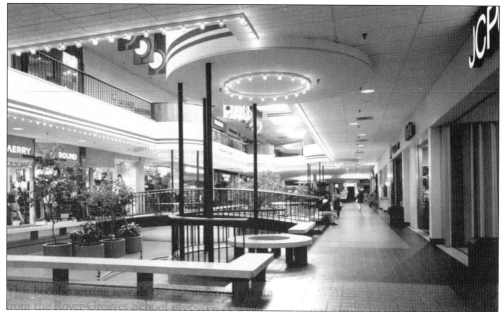

Here another space is transformed as designers plan the updating of another area of the Plaza. The "before" photograph (above) was given to the designer, and a new plan was developed (below). This latest renovation has transformed the Court and Plaza at King of Prussia into, arguably, the largest shopping complex in the country, with over three million square feet of retail space. This mall with over 400 stores helps to attract over 10 million visitors a year to King of Prussia. (Courtesy Kravco Simon.)

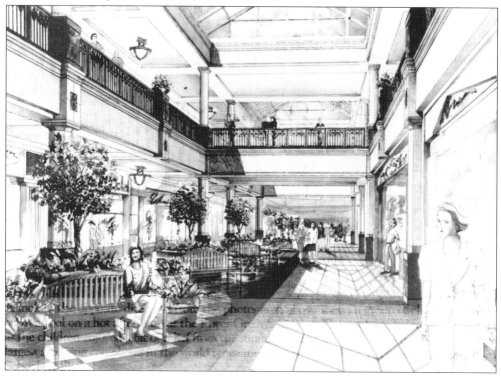

Six

NOR-VIEW FARM

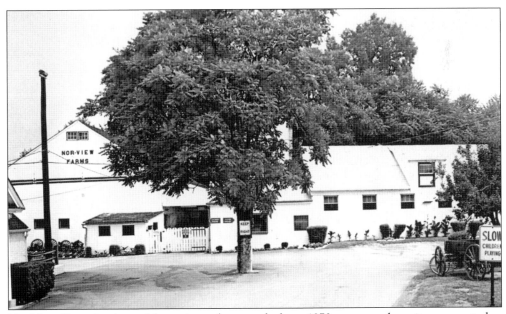

Nor-View Farm is pictured here, in a photograph from 1970, very much as it appears today. (Courtesy Ken DiGiambattista.)

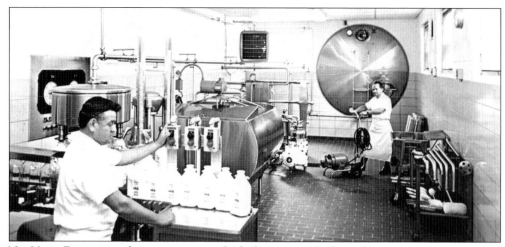

Nor-View Farm is a dairy operation which began in 1922, and once covered over 300 acres, including Sweetbriar, Cinnamon Hill, and Merion View. In this photograph from 1970, owners Frank and Joe DiGiambattista are seen hard at work in the dairy. (Courtesy Ken DiGiambattista.)

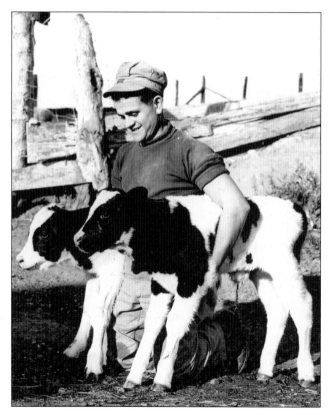

A photograph from the 1960s shows Frank DiGiambattista with two newborn calves. As one might imagine, children from surrounding communities were drawn to the farm and its animals. The children were often given jobs around the farm and in the dairy farm store. (Courtesy Ken DiGiambattista.)

"The Big Chicken" as it is known, is actually a rooster, and stands proudly at the entrance to Nor-View Farm. Next to the King of Prussia Inn, it's the most recognizable icon in King of Prussia. It has been replaced once, and repaired several times at an auto body shop due to vandalism. (Courtesy Ken DiGiambattista.)

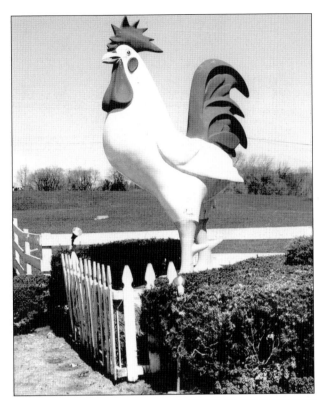

Opposite the rooster is the entrance to Nor-View Farm as seen in this photograph from 1970. The farm is owned by Upper Merion Township and still looks much like it did when this photograph was taken.

The Nor-View Dairy Farm Store is seen here in this photograph from 1970. In 1972, the farm began selling ice cream, and in 1977 a petting zoo was added. The farm would continue to be a very busy place. (Courtesy Ken DiGiambattista.)

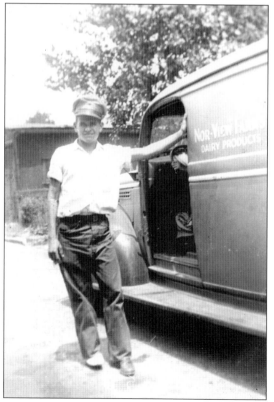

This is another photograph, this time from 1945, of Frank DiGiambattista with a cast on his right foot. Frank is about to embark on his milk delivery route which the family ran until 1962 when they stopped in favor of a dairy farm store. (Courtesy Ken DiGiambattista.)

Another photograph of Frank shows him busy at work in the farm store. The farm began as a vegetable farm, but evolved into the milk delivery business in 1934 as the working farmland dwindled. (Courtesy Ken DiGiambattista.)

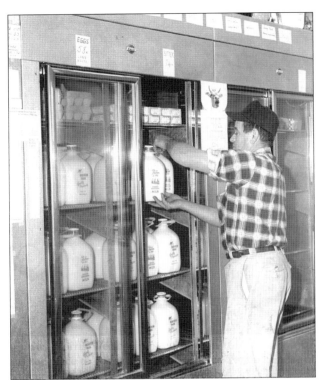

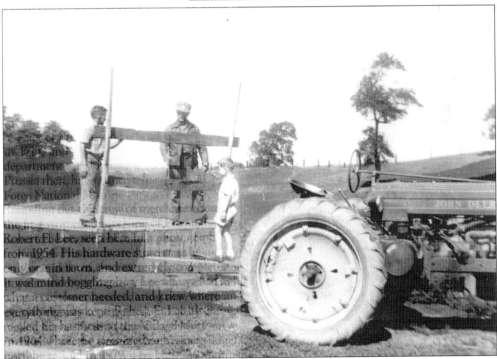

This is a picture of Grandfather Salvatore DiGiambattista instructing two children eager to help with the work. The view of the farmland looking out over Lowell Terrace has changed very little over the years. (Courtesy Ken DiGiambattista.)

This photograph shows the DiGiambattista children posing for a picture in front of their first farm truck. In the front row is Tony on the left, Gisella in the center, and Frank on the right. In addition to the farmland in King of Prussia, the family also owned 117 acres of land in Oaks, Pennsylvania, which would later be taken for the Route 422 bypass. (Courtesy Ken DiGiambattista.)

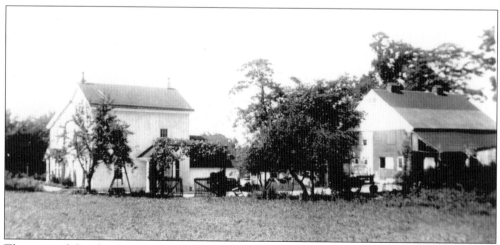

The original farmhouse is pictured here in the 1940s taken from the direction of Dartmouth Drive. The farm was purchased by Salvatore DiGiambattista, a farmer from Italy, for $4,500. The majority of the money was borrowed from friends and family on a handshake. (Courtesy Ken DiGiambattista.)

Seven

FOOD, LODGING, AND ENTERTAINMENT

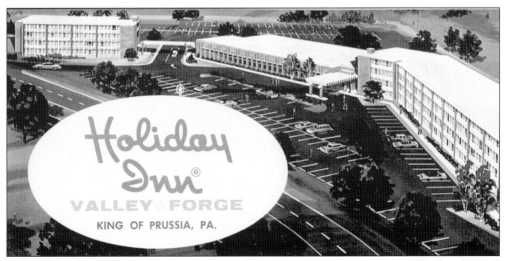

The Holiday Inn in King of Prussia is depicted in an artist's rendering in the 1970s brochure. It closed in 2003, reopening soon after as the Crown Plaza.

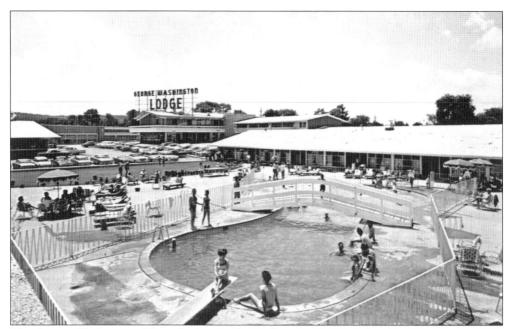

The George Washington Motor Lodge was located on U.S. 202 south, where Home Depot sits today. It was a modern 300 room air conditioned facility, with telephones, television and HiFi, indoor and outdoor swimming pools, and a cocktail lounge, according to the back of these postcards from the early 1960s. The author fondly remembers the grand opening, with helicopter rides, and swimming in the pools for all, exactly like the postcard above. The postcard below shows the indoor pool, with which the author was particularly enamored as a child.

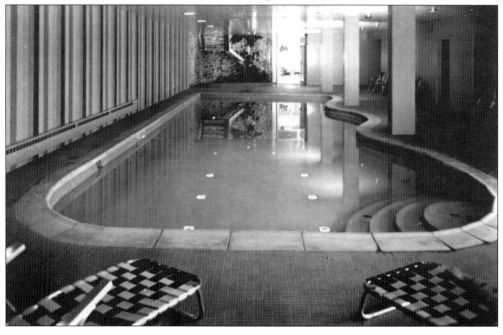

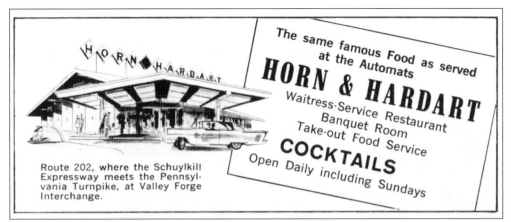

Horn and Hardart Restaurant was adjacent to the George Washington Motor Lodge. This was a familiar place to take the family for an inexpensive and satisfying meal. The building morphed into several other restaurants over the years, most notably Steak and Brew, Aspen, and Sportsters.

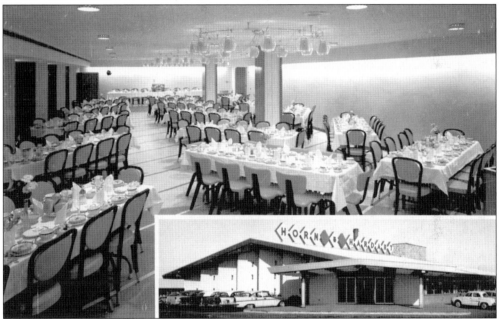

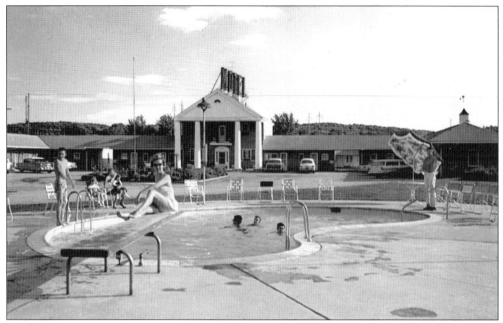

The General Lafayette Motel once stood on U.S. 202 north and King of Prussia Road, where Motel 6 is now located. It was one of many motels in the area. The author recalls working at the Mobil Service Station next door, and using the pool to cool off after a long, hot summer shift.

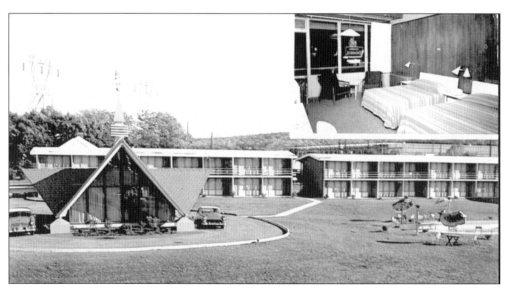

Howard Johnson's Motor Lodge was located at the intersection of U.S. 202 and Gulph Road, where the Best Western Inn at King of Prussia is now situated. It was also the site of Wood's Driving Range in the 1940s and 1950s.

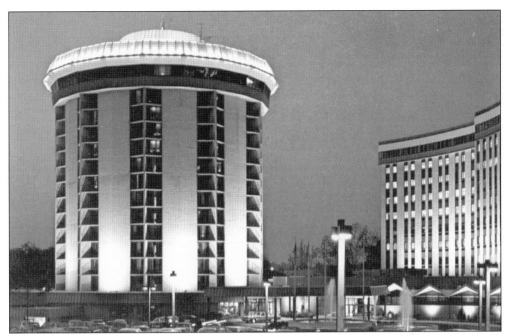

The Sheraton Valley Forge Resort Hotel, now the Radisson Valley Forge Hotel, was built in the early 1970s amid turmoil surrounding its owner J. Leon Altemose's use of non-union workers to build the complex. On June 5, 1972, approximately 1,000 men, associated with a local union, arrived on buses at 7:30 a.m. causing over $300,000 in damage to equipment, by overturning vehicles and setting fires. They also prevented the fire company from extinguishing the blaze. The project was finally completed, as seen here in this postcard from the early 1970s. (Courtesy Vincent Martino Jr.)

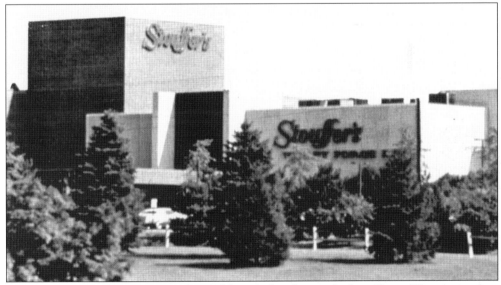

In preparation for the Bicentennial in 1976, many hotels were built in King of Prussia, in close proximity to Valley Forge. Stouffers Valley Forge was built with the celebration in mind and to accommodate shoppers at the mall. It still stands today as the Sheraton Park Ridge. (Courtesy Vincent Martino Jr.)

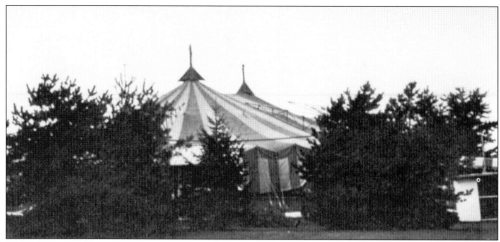

The Valley Forge Music Circus was down the road a piece from King of Prussia, nevertheless, many of the entertainers who performed there would take up lodging in King of Prussia. In a concept originated by Shelly Gross, Lee Guber, Frank Ford, and other broadcast pioneers the Valley Forge Music Circus, and later the Valley Forge Music Fair, was part of a prestigious chain of theatre-in-the-round venues that brought big-name entertainment to the area. With the advent of Atlantic City, attendance dropped off, and the property was closed and later torn down. In its place is a bookstore and a shopping center. (Top photograph courtesy Chamber of Commerce; bottom photograph courtesy Vincent Martino Jr.)

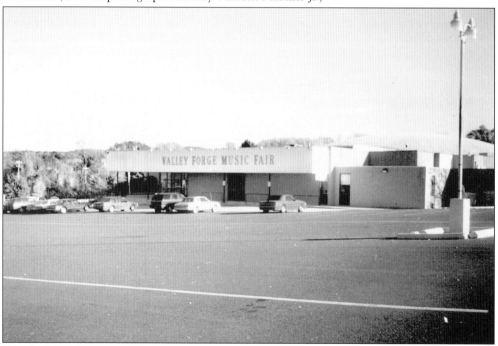

Tally Ho

RESORT

HOTEL — MOTEL

*Luxurious
Motel — Hotel
Living*

Gracious Dining

Complete Meeting
Facilities

The Tally Ho Resort and the Valley Forge Motor Court are worthy of mention as they were located adjacent to and across U.S. 202 from the Music Circus (and Music Fair). They were a direct result of the need for expansion along the U.S. 202 corridor, a phenomenon that would plague King of Prussia with large amounts of traffic for years to come. The Tally Ho was torn down when the Music Fair was built (notice the Music Circus tent in the background), and a portion of the Valley Forge Motor Court still exists today. Interestingly, questions surrounding the whereabouts of the sign on the left side of the postcard (below) have been asked quite frequently by travelers revisiting the area in recent years. (Courtesy Vincent Martino Jr.)

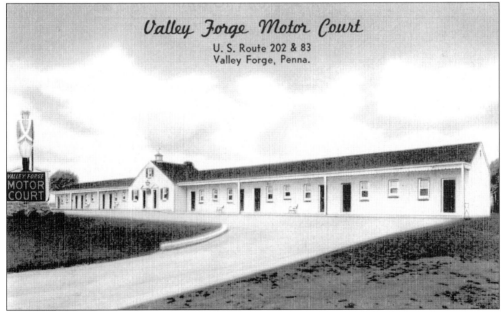

Valley Forge Motor Court

U. S. Route 202 & 83
Valley Forge, Penna.

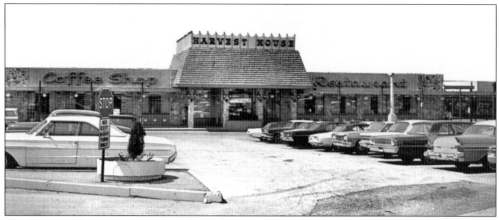

The Harvest House was one of the first restaurants in the King of Prussia Plaza and one of the last to give way to renovation in the late 1990s, under the name Ground Round. It was a terrific oasis when in need of sustenance from a hard day of shopping at the mall.

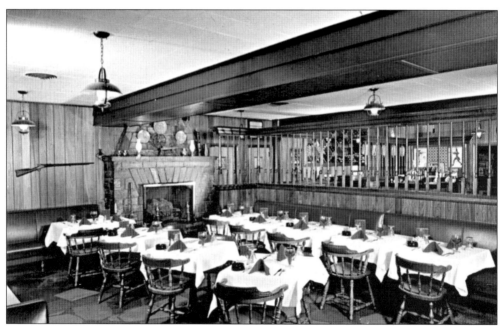

Johnny Kamuca's Valley Forge Tavern was located on U.S. 202 north just past what is the Motel 6 today. The building is still there and is currently a rug store. The back of this postcard reads, "intimate fireside dining . . . Cocktails, Sandwiches, Luncheons . . . Dinners ('til 11 p.m.) . . . Late Suppers." This was the place to go after a night at the Valley Forge Music Fair for a great late night snack, and the open-faced steak sandwiches were excellent.

Eight

SCHOOLS, CHURCHES, AND SERVICES

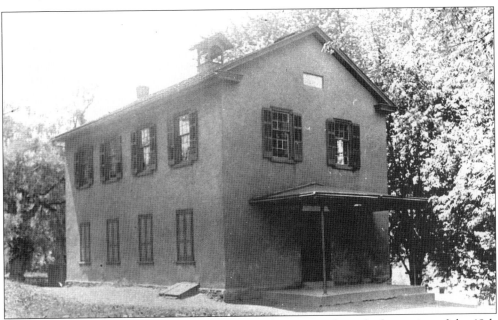

An unidentified King of Prussia school is seen in this picture from the beginning of the 19th century. It closely resembles the Evergreen School, or the Gulph Christian School, but with subtle differences. Like early mills, many early schools resembled one another. (Courtesy Upper Merion Township Public Library.)

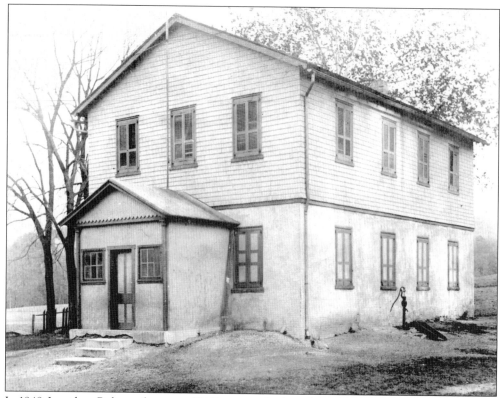

In 1848, Jonathan Roberts, farmer and U.S. senator, built a school for use by the poor children who had to walk to the Union School from the mill workers' houses on Croton Road. A 10 acre site was set aside, and the first school was built mostly from logs. This photograph, from an undetermined date, shows the second school. (Courtesy Upper Merion Township Public Library.)

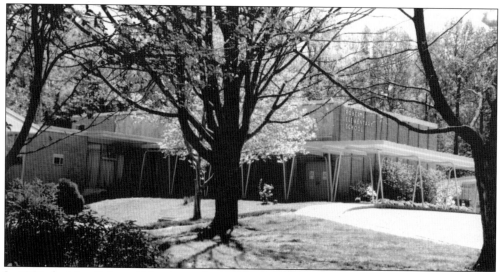

In 1958, the New Roberts School, seen here in a photograph from the 1990s, was built on the 10 acre property adjacent to the old school, which by this time had deteriorated to the point where all that was left was a portion of the back wall and a stone foundation. (Courtesy Patty Volpi.)

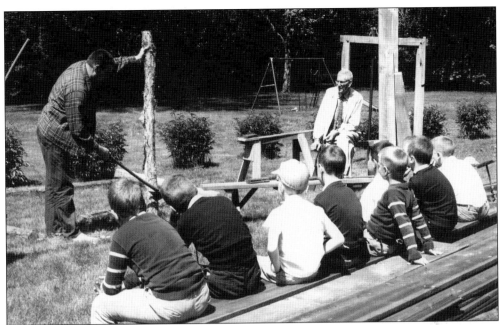

The King of Prussia Historical Society decided it was in the best interest of the community to restore the Old Roberts School to its former glory, and a monumental fundraising effort began. The project also presented a marvelous opportunity to teach young people about the process. Society members, Dr. Robert May (left) and L. W. Morrison (right), can be seen in this photograph from 1962 teaching shelter construction, beginning with the proper use of the felling axe, broad axe, and adz. (Courtesy King of Prussia Historical Society.)

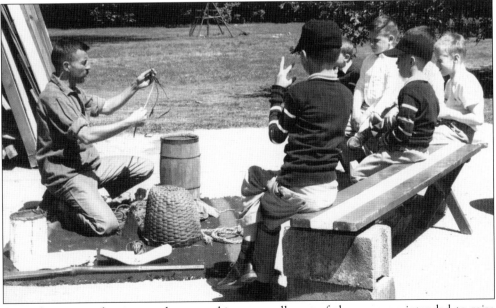

Animal trapping, farming, and rope making were all part of the program intended to raise awareness of our past. Here, Per Guldbeck, research associate of the New York Historical Association staff, instructs students from the Episcopal Academy. (Courtesy King of Prussia Historical Society.)

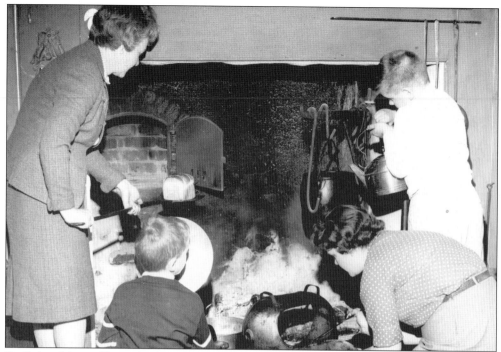

Dr. Robert May and his wife, Blair May, were instrumental in promoting the great work of the King of Prussia Historical Society, as it pertained to the restoration of Old Roberts School and other important projects. In this photograph taken in 1962, Blair May (right) can be seen instructing third grade students and parents in meal preparation the old fashioned way. (Courtesy King of Prussia Historical Society.)

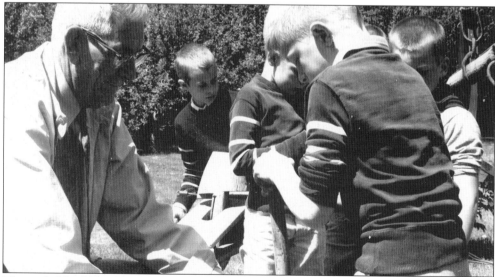

The roof of the Old Roberts School was made of cedar shakes (shingles). The author's grandfather, L. W. Morrison, contacted his former employer Philadelphia Electric Company, and soon a large cedar telephone pole was delivered to the site. Here he can be seen cutting the pole into cedar shakes using a schnitzel bunk, as a group of students eagerly observe. (Courtesy King of Prussia Historical Society.)

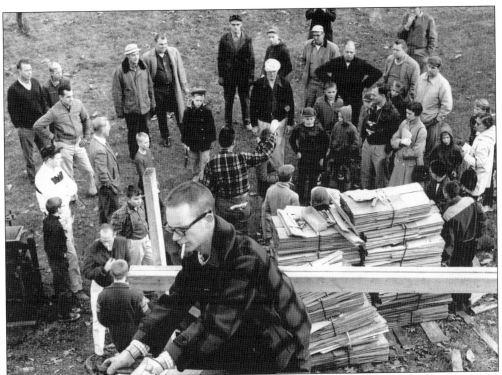

The Historical Society called upon every friend and family member in the area to assist with the effort to restore the old school. Here we see father and son teams being organized for a roof shingling contest. (Courtesy Upper Merion Township Public Library.)

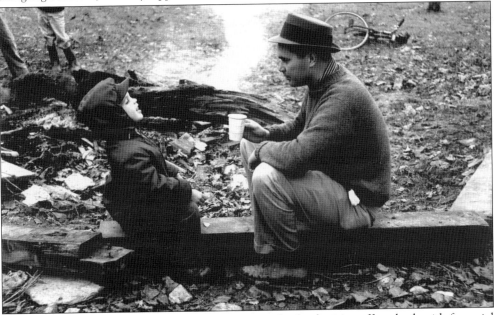

The community responded in a very positive way to the fund raising effort, both with financial contributions and volunteers. Pictured here is a father and son taking a break by the fire and enjoying a cup of hot cider. (Courtesy King of Prussia Historical Society.)

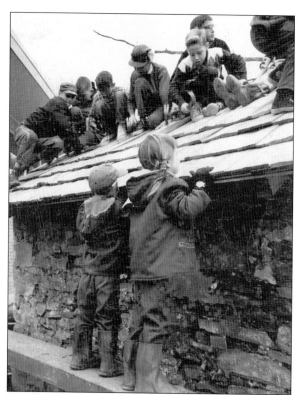

Every volunteer was put to work on the project no matter what age. Here a group of children can be seen lending a hand by shingling the roof of the privy. The author can also be seen doing his part in the very upper left of the picture. (Courtesy Upper Merion Township Public Library.)

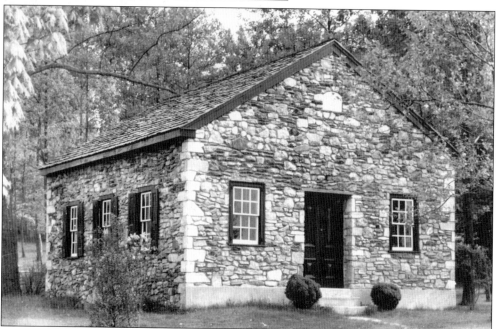

The Old Roberts School is seen in this photograph shortly after the restoration effort. Under the watchful eye and constant care of the Upper Merion Park and Historic Foundation, the school remains a monument to historic preservation. (Courtesy Upper Merion Township Public Library.)

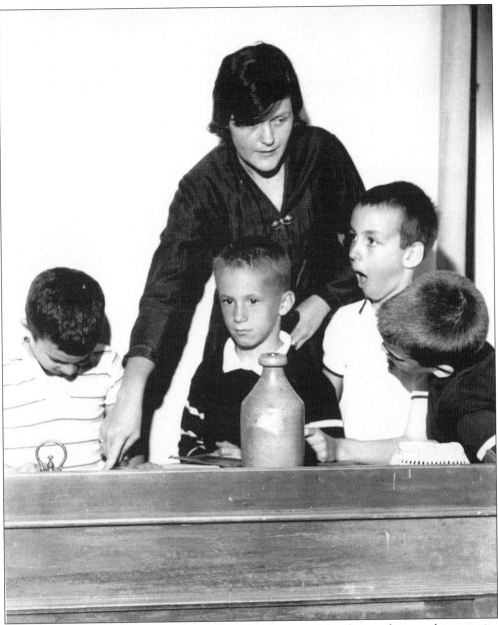

Since its restoration, the Old Roberts School has been used for classes where students receive a glimpse of how school was conducted long ago. An 1848 teacher interacts with 1962 students from the Episcopal Academy at her desk. (Courtesy King of Prussia Historical Society.)

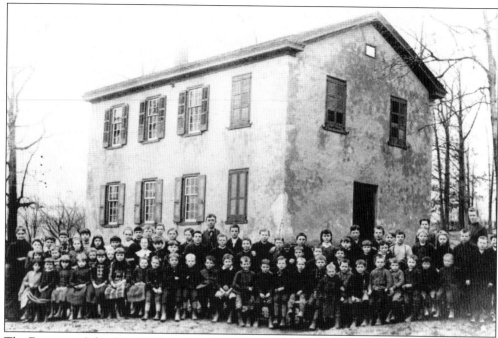

The Evergreen School was built in Port Kennedy in 1848, deriving its name from being situated in a grove of pine trees. This two story, two room structure housed 10 grades. The school was damaged by tornadoes in 1923 and abandoned in 1927. (Courtesy Upper Merion Township Public Library.)

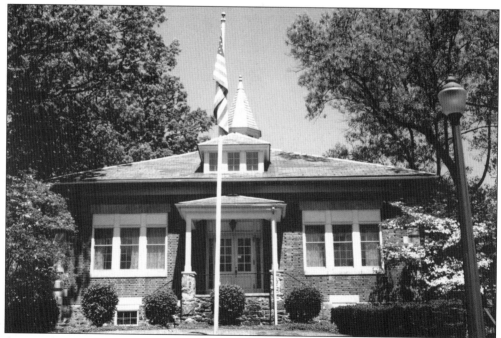

A new school, renamed Port Kennedy School was built in 1912. It had four classrooms on one floor, and was used by students in grades 9 and 10. It was closed permanently in 1960, but remains today as an office building, as seen here in this photograph from the spring of 2005.

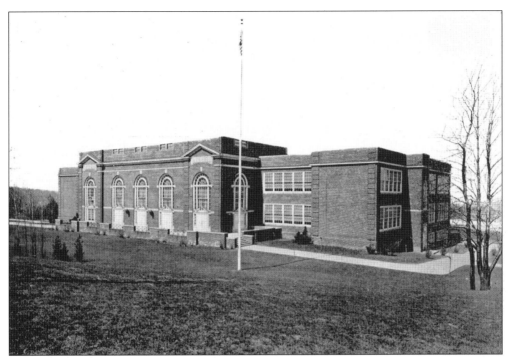

The Upper Merion High School is seen here in a yearbook photograph from 1938. Built in 1930, it housed both elementary and secondary grades, and in 1934 the school hosted its first graduating class of 57 students. The school, located at Gulph and Henderson Roads, served the students of the community for many years. Due to its exceptional location, it still exists as an office building. (Courtesy Emma Carson.)

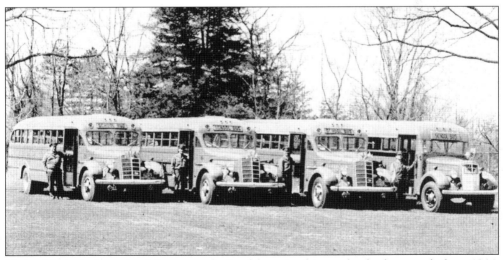

Upper Merion's first school buses are depicted here in this yearbook photograph from 1944. This fleet served the entire community and carried students of all grades to the unified school. (Courtesy Emma Carson.)

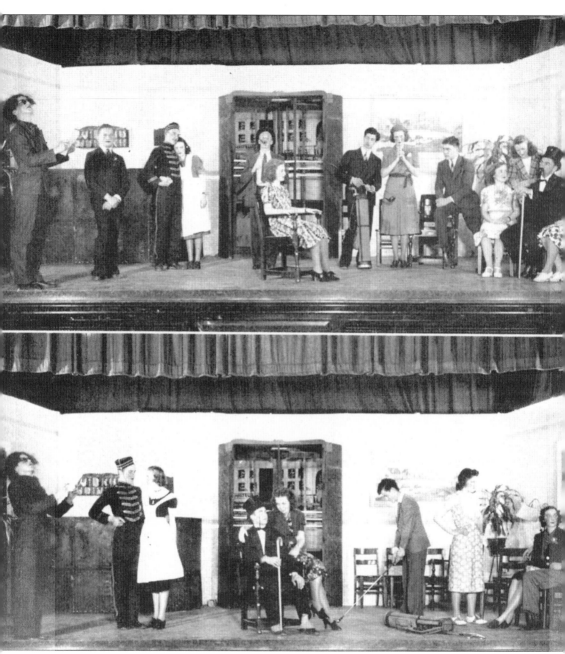

These scenes from a student production entitled *It's Great to be Crazy* were shot for a yearbook photograph in 1939. The play was performed in March, and ran for two days. (Courtesy Emma Carson.)

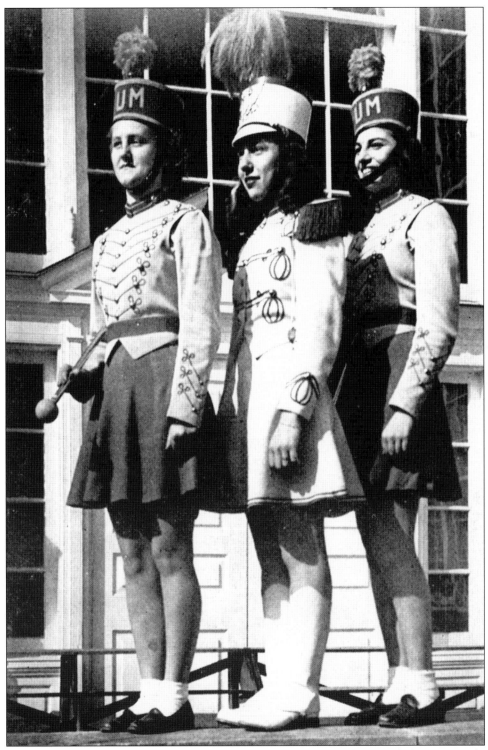
The Upper Merionettes pose proudly at attention for this yearbook photograph from 1946. They helped lead the marching band and cheered the Spartans on to victory. (Courtesy Emma Carson.)

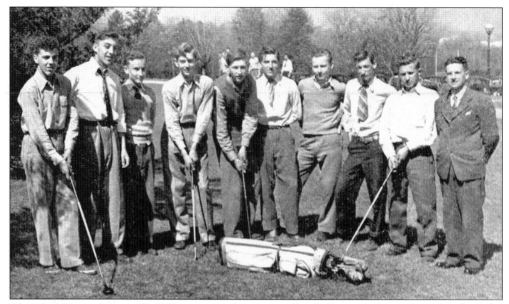

The 1946 Upper Merion Golf Team poses for this yearbook photograph on the grounds of the school, which were also used to practice driving. (Courtesy Emma Carson.)

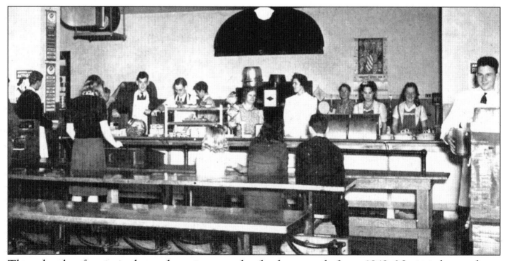

The school cafeteria is shown here in a yearbook photograph from 1942. Notice the students behind the counter serving food. (Courtesy Emma Carson.)

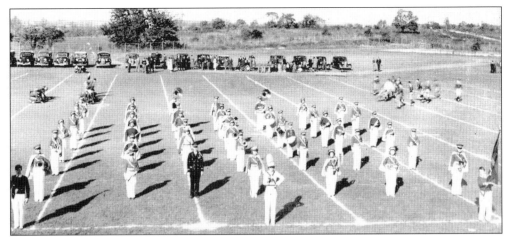

The Upper Merion High School Band poses for a 1938 yearbook photograph. Notice the open area behind the cars in the background that would become Gulph Elementary School in 1953. (Courtesy Emma Carson.)

A typical school day in 1946 is depicted by this photograph as students are seen during a break between classes. (Courtesy Emma Carson.)

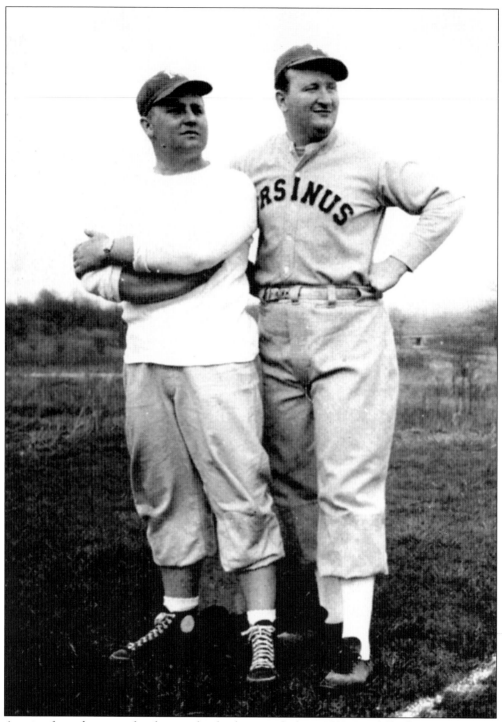

A pair of coaches pose for this yearbook photograph from 1939. It's difficult to explain the Ursinus uniform, except that it may have been a day of scouting. (Courtesy Emma Carson.)

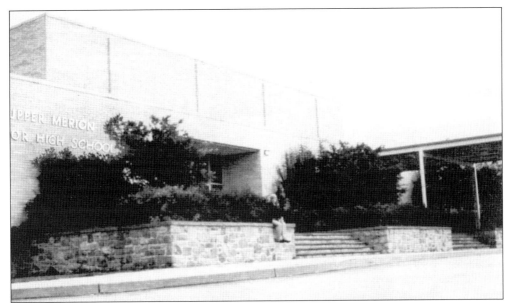

The Upper Merion Area School District built a new high school in 1960 and finally separated the secondary grades. This would turn out to be quite timely, as the Boroughs of Bridgeport and West Conshohocken would become part of the district in 1966. (Courtesy Chamber of Commerce.)

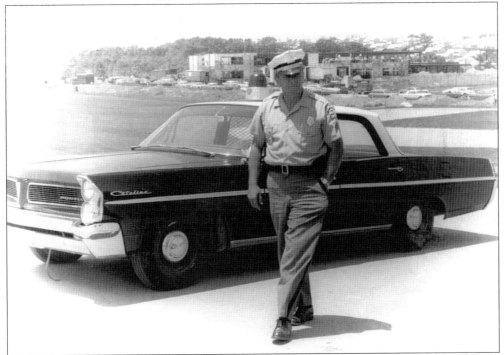

Sgt. Aloysius "Al" Humay poses for a photograph in the foreground, as work continues on the new Upper Merion Area Junior High School in the background, which was built in 1964. Students in the seventh through ninth grades were then moved from Henderson Road to their own facility, which would serve the community until 2005 when an expansion project commenced. (Courtesy Upper Merion Police Department.)

The Henderson Cemetery is seen in this photograph with the former high school in the background. Samuel Henderson was a very prosperous member of the community embracing stone cutting and marble quarrying around 1798. (Courtesy Upper Merion Township Public Library.)

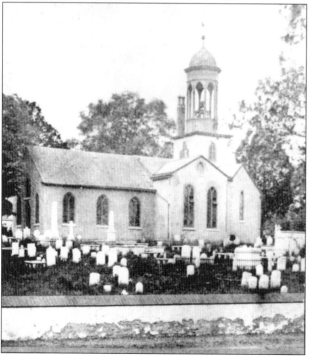

Christ Church, Old Swedes, is depicted here as it appeared prior to 1880. It was organized in 1733 originally as Lutheran, it is now an Episcopal congregation. On December 13, 1777, seeing candlelight in the church, General Washington and his men approached seeking food and clothing. The army camped there for a short period prior to their march through Gulph Mills to Valley Forge. There are 10 marked graves (and several unmarked) of Revolutionary Army soldiers in the cemetery. (Courtesy Ed Dybicz.)

IN MEMORY AND IN HONOR OF
OUR GREAT AMERICAN
ADVENTURERS AND PIONEERS
THE REV. NICHOLAS COLLIN D. D.,
LAST OF THE OLD SWEDISH PRIESTS,
GEORGE WASHINGTON
BENJAMIN FRANKLIN
ANTHONY WAYNE

THE ADVENTURERS.

THEY SIT AT HOME AND THEY DREAM AND DALLY
RAKING THE EMBERS OF LONG-DEAD YEARS,
BUT YE GO DOWN TO THE HAUNTED VALLEY
LIGHT-HEARTED PIONEERS,
BUT THE FLAME OF GOD THROUGH YOUR
SPIRIT STIRS,
ADVENTURERS—O, ADVENTURERS!

DEDICATED JUNE 1942

A lovely plaque adorns the wall of Christ Church, Old Swedes. It needs no explanation.

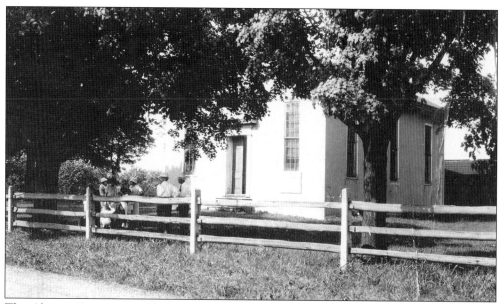

The Abrams Community Chapel can be seen here on a bright, beautiful day in 1934. The church was built in 1868 and still stands today on Henderson Road. (Courtesy King of Prussia Historical Society.)

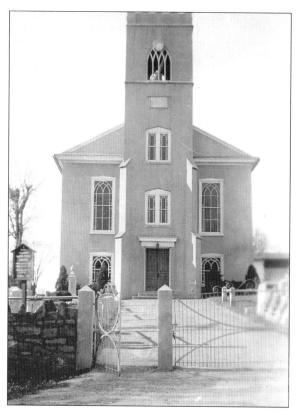

The First Presbyterian Church of Port Kennedy was organized on March 20, 1845, and with the exception of the bell tower addition seen here, has changed very little. A notice placed in the *Norristown Registered Montgomery Democrat* in 1844 said that the cornerstone of the "Presbyterian Church edifice about to be erected at Port Kennedy, will, by Divine permission, be laid on Thursday the 31, at 11:00 a.m." (Courtesy Upper Merion Township Archive.)

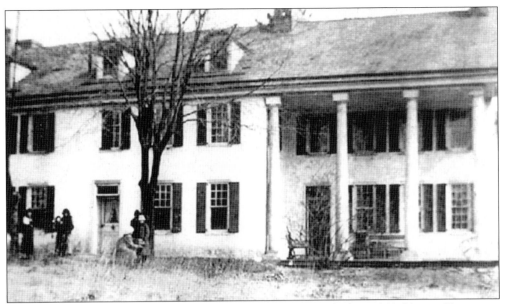

Prior to the cornerstone of Trinity Episcopal Church being laid in 1914, Varian House was used for services. It was located at 198 Crest Way, in Gulph Mills, and served as sanctuary in 1913–1914. Trinity still serves the community today with church services and a very popular preschool. (Courtesy Mary Raichle.)

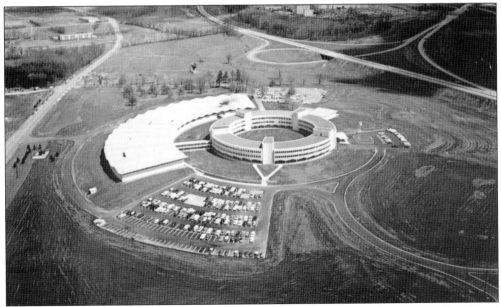

The National Offices of the American Baptist Churches, seen here, has been fondly referred to as "the Holy Donut". This fascinating structure with its landscaped center hosts the circular offices and the graphic arts building that houses Judson Press and its printing plant.

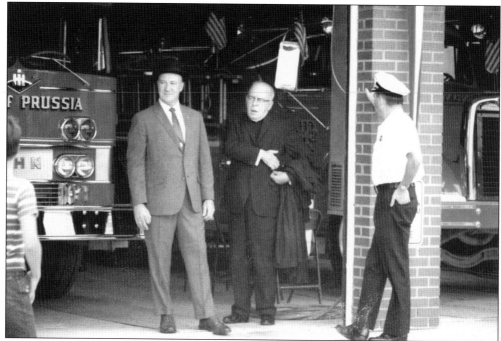

In 1950, the King of Prussia Volunteer Fire Company No. 1 was formed. The King of Prussia firehouse (above) was built on Allendale Road, and still serves the community today. This photograph shows Jack Brennan (left), former police lieutenant, and Rev. James M. McGrory (center) from Mother of Divine Providence Catholic Church, along with an unidentified fire policeman outside the station. The photograph below, from the spring of 2005, shows the substation on Beidler Road, built in 1970. (Courtesy Upper Merion Township.)

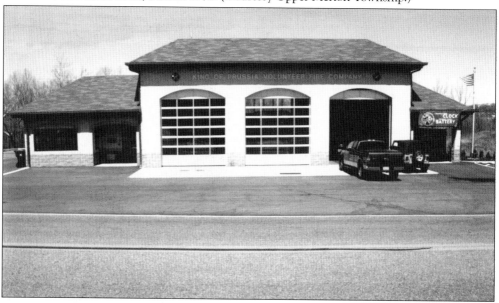

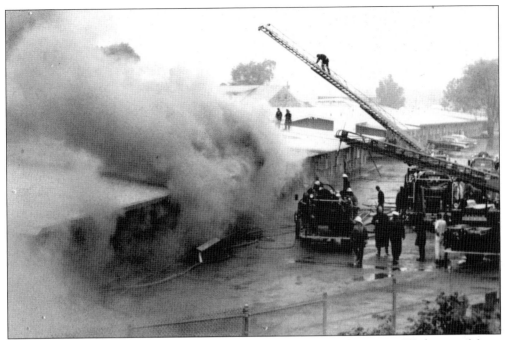

The King of Prussia Fire Company is seen responding to a fire at the George Washington Motor Lodge in 1962. The buildings shared a common attic, and 10 units were destroyed as well as one fatality. (Courtesy Ed Dybicz.)

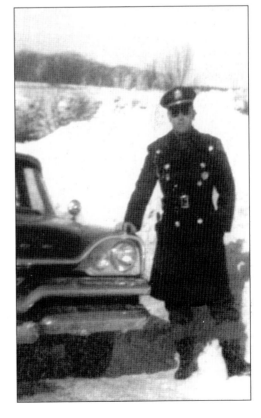

Upper Merion Police Officer Carl DeHaven is seen here with his Dodge Pursuit in a photograph taken in front of the Valley Forge Golf Course in February of 1957. (Courtesy Upper Merion Police Department.)

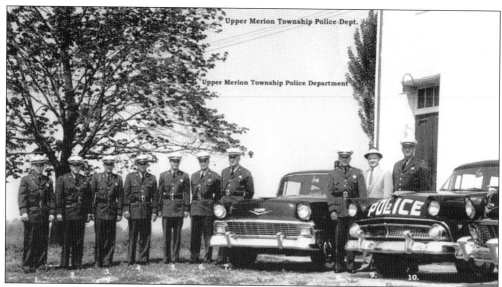

A group of Upper Merion Police Officers is seen here in the above photograph, from the late 1950s, posing in front of the Stewart Fund Hall at Allendale Road and DeKalb Pike (U.S. 202). The photograph below was taken in 1964, and the increase in the number of officers is evident. The department was created in 1930, when the township supervisors "appointed Lester Smull of Mount Pleasant a regular township policeman." This action came in the aftermath of the murder of a Swedesburg grocer on April 9, 1929. Somewhere, a photograph exists of Officer Smull and his first patrol car, however, only copies can be found today. (Courtesy Upper Marion Police Department.)

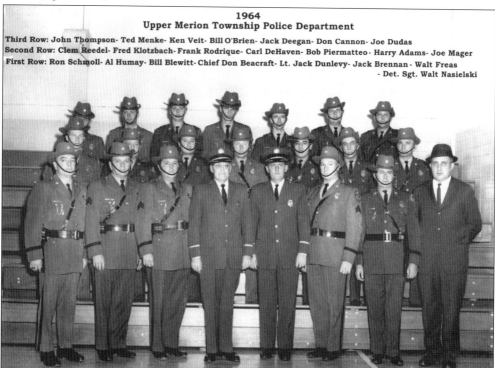

1964
Upper Merion Township Police Department

Third Row: John Thompson- Ted Menke- Ken Veit- Bill O'Brien- Jack Deegan- Don Cannon- Joe Dudas
Second Row: Clem Reedel- Fred Klotzbach- Frank Rodrique- Carl DeHaven- Bob Piermatteo- Harry Adams- Joe Mager
First Row: Ron Schmoll- Al Humay- Bill Blewitt- Chief Don Beacraft- Lt. Jack Dunlevy- Jack Brennan- Walt Freas
- Det. Sgt. Walt Nasielski

Nine

HERE TODAY, GONE TOMORROW?

A wonderful example of "Swedish Stairs" can be seen in this photograph from 1956, shortly before this home in Gulph Mills was destroyed. Notice the efficient use of space as the area behind the stairs, next to the mantle, is used for storage. Private ownership is never a guarantee that a historic property will survive. (Courtesy Upper Merion Township Public Library.)

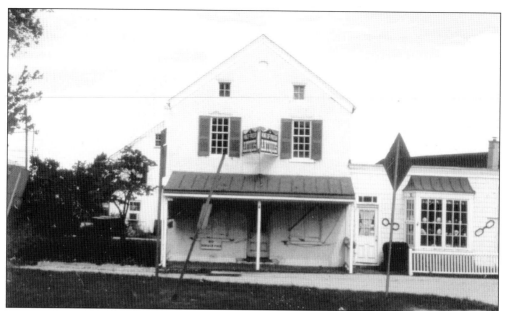

In 1984, the King of Prussia Antique Shop and General Store closed its doors for good. The property had been sold to Mobil Oil Corporation to expand their facility at the corner of Gulph Road and DeKalb Pike (U.S. 202). Efforts were made to save the building as well as those surrounding it in an attempt to restore the center of town and create a learning center complete with museum and archival restoration center. Unfortunately, an agreement with Mobil was never reached. The photograph above shows the building just before demolition, and the photograph below shows it just after. (Courtesy King of Prussia Historical Society.)

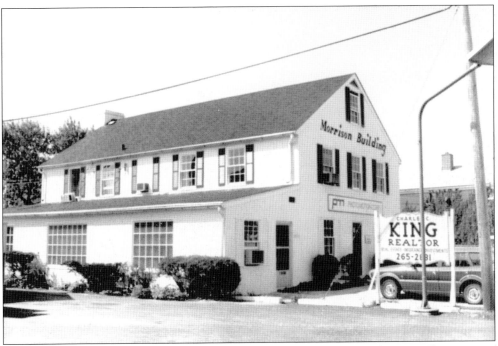

This building sat just behind the Antique Shop and General Store in the Reesville section of King of Prussia and was originally built to house the King of Prussia Post Office when it outgrew its former facility. By the time the building was finished, the town had outgrown it as well, and the Post Office was moved to Town Center Road, in the Red Hill section of King of Prussia. This building was also destroyed in 1984.

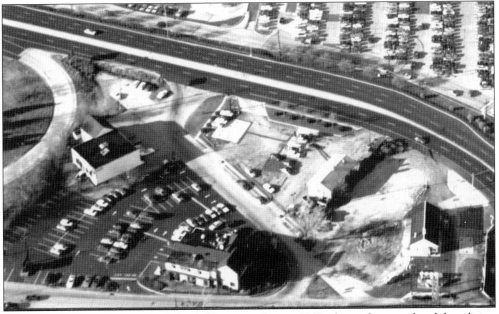

This aerial view of the center of King of Prussia, taken in 1988, shows the completed demolition of both buildings. The King of Prussia Inn can be seen in the lower left prior to being moved, and the mall is at the top of the picture. (Courtesy Kravco Simon.)

The Martin's Dam Club is located at the intersection of Croton and Warner roads and was built to take advantage of an existing lake formed by a dam used to feed the Croton Mill. Although the club still exists today, swimming in the lake is no longer permitted.

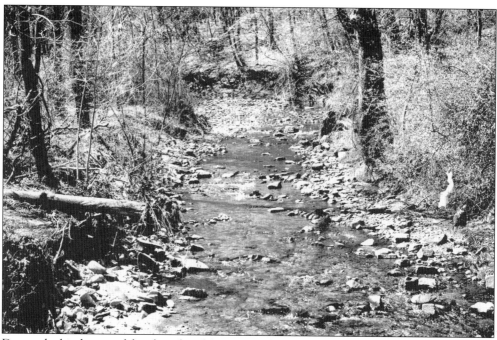

Due to the kindness and forethought of Anna French McKaig, a 50 acre portion of the French's Hill section of King of Prussia was set aside for the township to use provided it remain primeval woodland. Today, the McKaig Nature Center covers 76 acres and is maintained by the Upper Merion Park and Historic Foundation along with a group of dedicated volunteers.

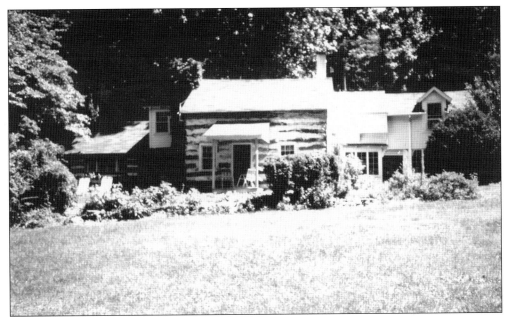

Situated on a 12 acre tract of woodland on Radnor Road, the Exley Log Cabin, seen here in a photograph from 1980, could possibly date to as early as 1684, according to historians. The architecture points to it being of Swedish origin, and Swedish trappers were known to have settled in the area as early as 1633. Today, it remains a beautifully restored and maintained home. (Courtesy King of Prussia Historical Society.)

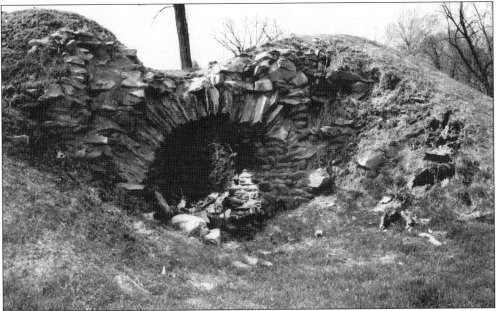

At the intersection of Brooks and Croton Roads in the Robertsville section of King of Prussia stands this example of one of the area's earliest essential industries. Limekilns were commonplace in the early days, due to the limestone deposits in the area, this one was run by the Brooke family. By 1845, Swedesburg became the third largest inland port for the shipment of lime coming from the Brooke Quarry and others.

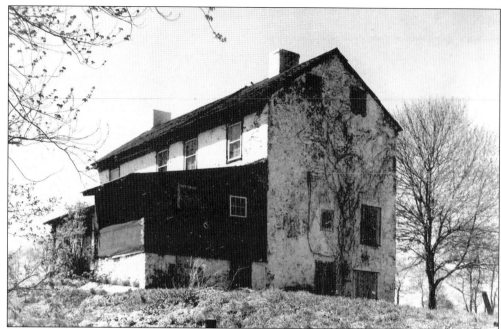

This lovely old house (above) and barn (below) were originally part of a 100 acre farm owned by Griffith Phillips who settled in King of Prussia in 1731. The farm was purchased from the Manor of Mount Joy, which William Penn gave his daughter Letitia, who later sold it to settlers. It was located near Allendale Road and First Avenue and abutted the farmstead of John Moore. Prior to their removal, to make way for an industrial park, the buildings were studied thoroughly to reveal their architectural history. The unfortunate part is that the interior details were of great significance, both pre- and post-Revolutionary, and were sold off in pieces prior to the buildings being razed. (Courtesy Upper Merion Township Public Library.)

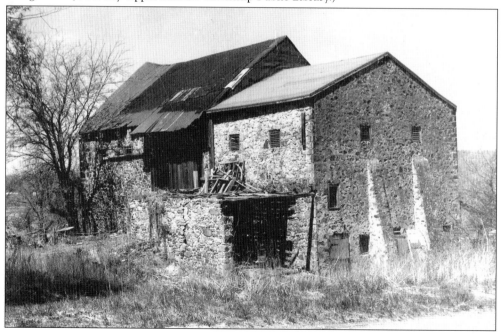

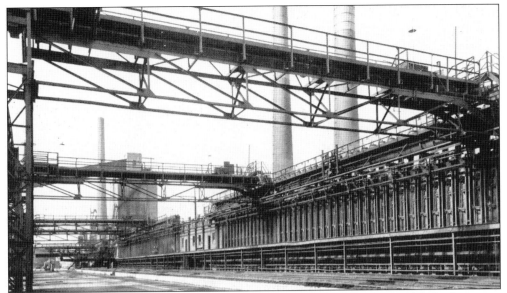

Batteries of coke ovens are seen in this picture from 1942 of the Rainey Wood Coke Company. Offices were located in Conshohocken while the plant seen here was located in Swedeland. By this time barge traffic was history, and everything shipped by rail. The rail cars were designated "RNWX," and can still be seen on the tracks along the river today. They are all that exist of this massive enterprise. (Courtesy Emma Carson.)

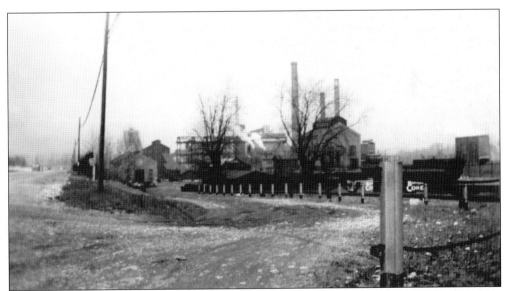

Alan Wood Steel Company operated from 1826 until 1978. This early photograph taken from River Road shows the steel factory in full operation. Alan Wood is known for supplying the steel used to make the *Spirit of St. Louis*. Many of the iron workers lived in Swedeland, and their homes and streets were laid out on the former Potts farm, whose family founded the Swede Iron Company in 1851. (Courtesy Upper Merion Township Archive.)

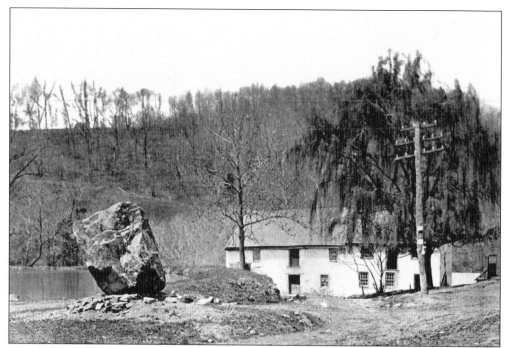

The Gulph Mill (above) was built in 1747 by Abram Nanna, along the banks of the Gulph Creek from which it derived its power. Washington would later write of the Gulph, "These grounds were the threshold to Valley Forge, and the story of that winter-a story of endurance, forbearance, and patriotism which will never grow old-had its beginnings here, at the six days' encampment by the old Gulph Mill." A fire in 1895 destroyed the mill, but for many years the despondent skeleton (below) remained as a local landmark. Evidence of the site, especially the ruined dam, is still evident today.

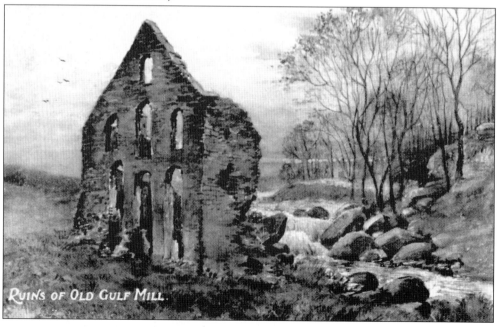

RUINS OF OLD GULF MILL.

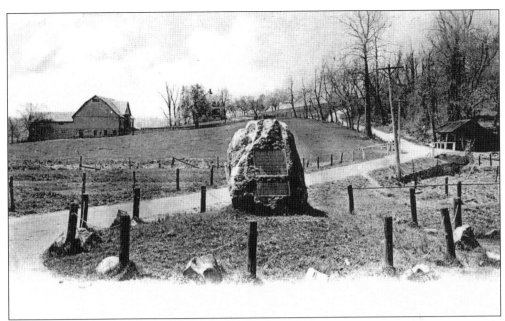

The Gulph Mills Memorial (above) consists of a large boulder, nine feet tall, taken from the adjacent hill and erected on a substantial foundation at the intersection of Montgomery Avenue and Gulph Road. Upon it is written "The main Continental Army commanded by Gen. Washington encamped in this immediate vicinity from December 13–19, 1777, before going into winter quarters in Valley Forge." It was erected in 1892 by the Pennsylvania Society of the Sons of the Revolution. In 1962, the memorial (right) was rededicated and moved to Upper Gulph and Gulph roads. It was later moved again and rests in Executive Estates Park, on Longview Road. (Courtesy Upper Merion Township Public Library.)

In 1917, the Hanging Rock in Gulph Mills (above) was in danger of being removed by the Pennsylvania Highway Department to provide a wider and safer highway. Distressed by this prospect, its owner, Mrs. J. Aubrey Anderson, donated the rock to the Valley Forge Historical Society in 1924 along with a plaque that was affixed to it which noted that Washington was encamped in the area on his way to Valley Forge in 1777. This worked for a time, but in 1980, the rock was again noted as a hazard to the ever increasing traffic in the area. A compromise was reached with the Pennsylvania Department of Transportation, and the rock was re-profiled (below). (Top photograph courtesy Upper Merion Township Public Library; bottom photograph courtesy King of Prussia Historical Society.)

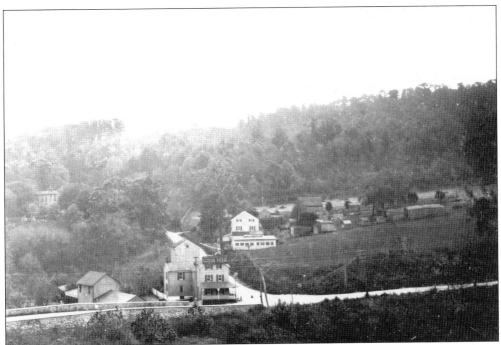

The town of Gulph Mills is seen here in this early photograph, then known as Bird-in-Hand. Theories suggest this picture dates to around 1911, because there was no high ground in the vicinity of where this picture was taken, it had to be shot from the Philadelphia and Western Trolley right-of-way. The Bird-in-Hand Hotel can be seen advertising "Lotus Beer" in the foreground. (Courtesy King of Prussia Historical Society.)

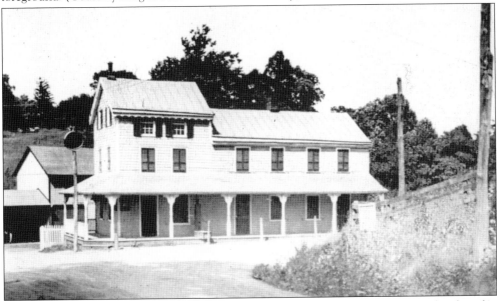

It was run by Frank L. Jones and was one of many in the area. All are gone today, but this photograph is a wonderful reminder of the interesting buildings that once graced our area. The Bird-in-Hand Hotel was torn down to make way for the Schuylkill Expressway (Interstate 76) in 1952. (Courtesy King of Prussia Historical Society.)

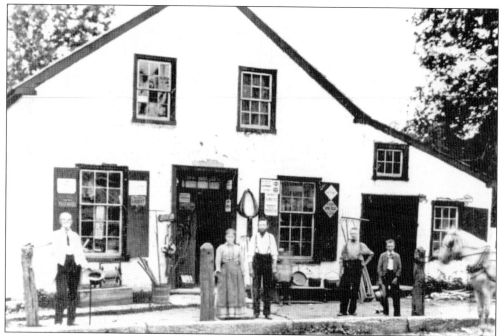

The Bird-in-Hand Store (above) is depicted in this photograph from 1900. The exact date of the store is not known, but it could have been an outbuilding of Lindsey Coates's grist mill, or part of John Shephard's chocolate mill, saw mill, or stone workshop as early as 1798. Records indicate that distillers from Pittsburg used Gulph Road on their way east to Philadelphia and often stopped at the store to unload a few barrels. The store has been remarkably well preserved over the years and still serves as a private residence today. The photograph below was taken in the late-1950s when Gulph Road still ran in front of the home. (Top photograph courtesy Upper Merion Township Public Library; bottom photograph courtesy King of Prussia Historical Society.)

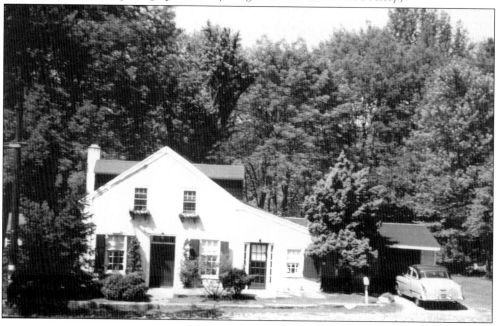

Poplar Lane is seen here, in a photograph from 1922, in a lovely snowstorm (above) and in the spring of 1935 (below), in the boxwood court of Percy's Garden. Poplar Lane was probably built around 1750 and was remodeled in the 1800s in the Greek Revival tradition of the 1820s. The house is associated with the Hughes family (c. 1680) and was once used as a church until Trinity Episcopal Church could be finished. (Courtesy Upper Merion Township Public Library.)

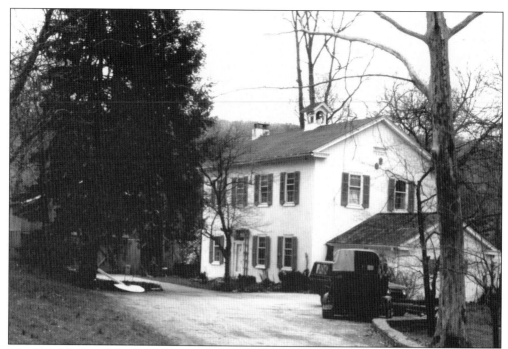

The Gulph Select School (1867) is seen here, beautifully converted into a lovely historic home. (Courtesy King of Prussia Historical Society.)

Gulph Road was laid out in 1713 from the Old Lancaster Road to the grist mill, and later to King of Prussia and beyond. It was an early road to the west, but because of the many twists and turns (made necessary by the protests of farmers who did not wish for a road to go through their land) it did not become a popular route. Here is a photograph of a mile marker on Gulph Road 18 miles from Philadelphia. (Courtesy King of Prussia Historical Society.)

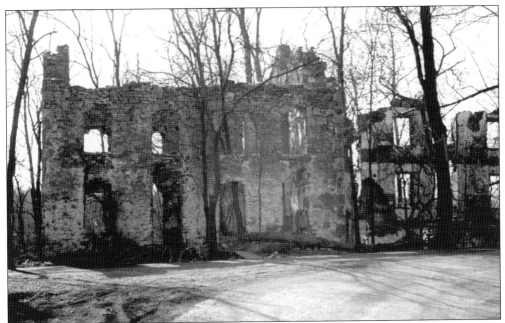

This former academy on Jones Road in the Gulph Mills section of Greater King of Prussia was destroyed without sufficient warning to permit photography, measuring, or studying the interior detail. (Courtesy King of Prussia Historical Society.)

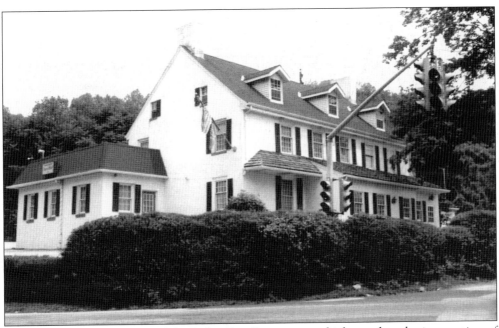

This photograph was taken of the Picket Post Restaurant, which stood at the intersection of Gulph Road and Old Gulph Road. This was originally General Washington's furthest outpost during the encampment at Valley Forge, which at one time was under the command of Aaron Burr. The location was as good then as it is now, as it still serves as a restaurant today named Savona. (Courtesy Upper Merion Township Public Library.)

Spring Hill (Walnut Grove) is one of the most beautiful examples of early American architecture to be found in this country. Built in 1803 by John and Hannah Hughes, it represents some very fine accomplishments by this pioneering family through farming their land and selling the timber it provided. The home remains a private residence today. (Courtesy King of Prussia Historical Society.)

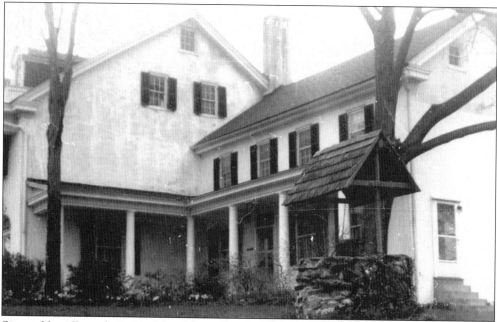

Swamp Vrass Farm dates from 1699 and was the home of the Roberts family, including Jonathan Roberts, U.S. senator from 1815 to 1821. In 1915, the home was sold to the Valley Forge Memorial Gardens Cemetery Association. The original home, called Buttonwood, has been restored and beautifully maintained.

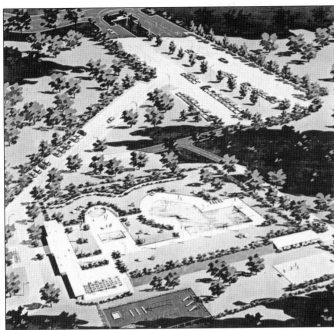

UPPER MERION
SWIM CLUB

Brownlee Road
Upper Merion Twp., Pa.

MEMBERSHIPS
AVAILABLE

The Upper Merion Swim Club is seen here in this postcard. It was a major attraction for residents in the Henderson section of Greater King of Prussia. The club was closed amid reports of contamination from Tyson's Dump nearby, one of five superfund sites in King of Prussia found to contain highly toxic substances.

For over 80 years there has been a restaurant at the corner of U.S. 202 and Gulph Road. This is a time-lapse photograph of Howard Johnson's Restaurant, taken on the evening of July 4, 1976, the nation's Bicentennial.

Samuel Tabak arrived in King of Prussia early in the 20th century. A Jewish merchant, Tabak operated stores in Norristown and Bridgeport. He purchased 73 acres of farmland on Eastburn Hill near Valley Forge Road. The springhouse still remains today as a wonderful example of totally restored elegance. (Courtesy Doris Freeman.)

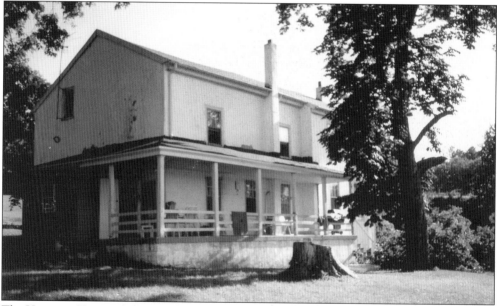

The Hampton House is located on the grounds of the Upper Merion Township Building, at Valley Forge and Henderson Roads. It is all that exists of an old farm, chosen as the site for local government after the Stewart Fund Hall was outgrown. It is an excellent example of a period Pennsylvania farmhouse, and it is the author's hope that it will be restored and used as a site to gather local artifacts, stories, and photographs, living on as a museum. (Courtesy King of Prussia Historical Society.)

Two King of Prussia citizens of note were Maj. William Hayman Holstein and his wife, Anna Morris Holstein. Both did military nursing during the Civil War, and both were founding members of the Centennial and Memorial Association of Valley Forge. This association is known for purchasing Washington's Headquarters in 1878, in order to preserve it for posterity. Their house is located on Henderson Road, just south of U.S. 202.

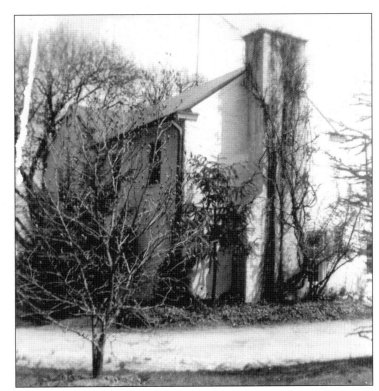

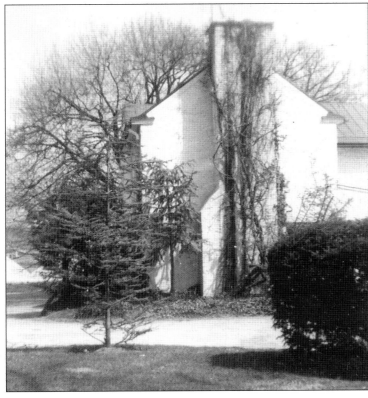

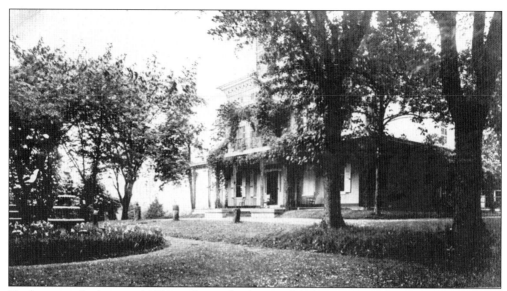

Kenhurst was built around 1750, and completely remodeled in 1860, to a magnificent Victorian design. It was the home of John Kennedy, one of the leading early industrialists in Greater King of Prussia and for whom Port Kennedy was named. The house featured an indoor bathroom, unique for its time. There were more than 50 houses, and 60 limekilns in Port Kennedy at the time, and the Kennedy's employed over 400 men. Most recently, the home became the Kennedy-Supplee Mansion Restaurant, but is now vacant. (Courtesy Vincent Martino Jr.)

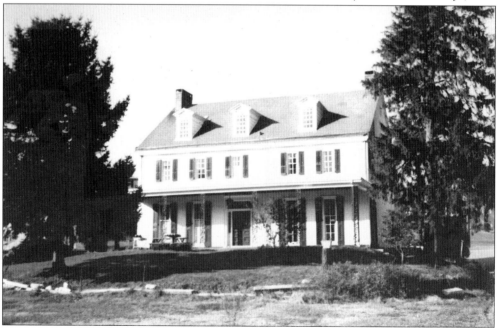

Samuel Henderson's home on Shoemaker Road is seen here in a photograph from 1970. Henderson was known as an energetic and prosperous man who ran a sizeable stone cutting operation from a quarry on the property. The house was purchased in 1964 by Domenic Pasquale, and turned into an office building. Pasquale is to be commended for keeping the architectural integrity of the original building. (Courtesy King of Prussia Historical Society.)

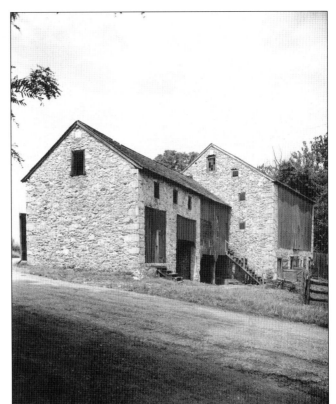

Samuel Henderson's barn is pictured here in a photograph taken in 1941 (right). It is located across the lane from his home and was built in 1799. The date stone includes the name I. Wright, who was the stonemason who set the stone. The barn has endured as seen in this photograph from the spring of 2002. It has been completely restored and serves as a small shopping center. (Courtesy Library of Congress.)

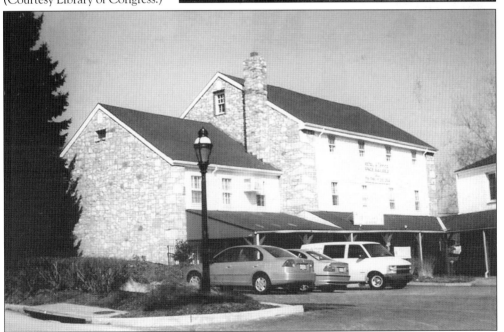

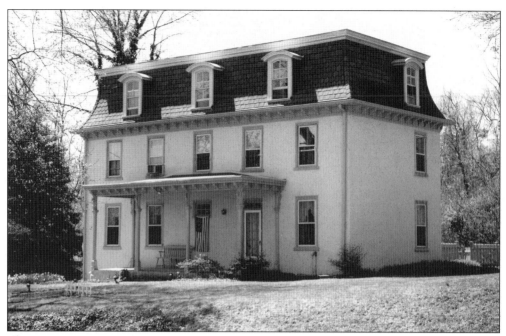

This is a recent picture of the home of Robert Morris, financier of the American Revolution. This house (above) located on Mancill Mill Road was completely remodeled in the late Victorian period with a Mansard Roof (c. 1858–1876). The original house was two stories and built of logs. There were also several outbuildings, one of which has been handsomely restored (below).

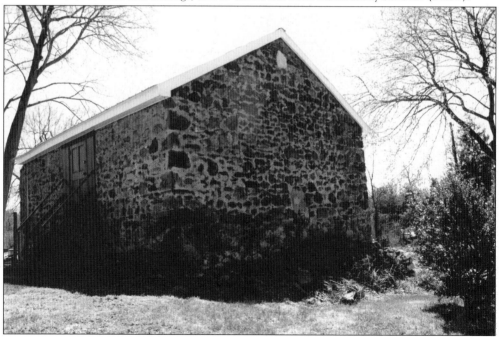

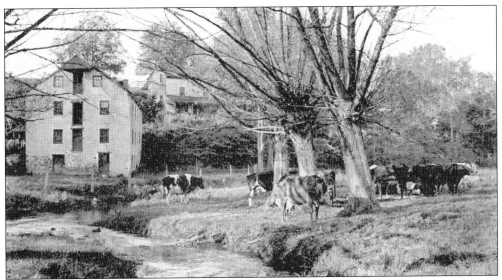

Robert Morris's grist mill began operation around 1747. Two views of the same mill are represented here. A postcard from around 1920 (above) shows the mill in relatively good condition. The postcard sold all over the area, including Valley Forge. The later view (below) from 1966 shows the addition of a railroad siding from the Trenton Cutoff and signaled the last days of the mill which shortly thereafter gave way to an industrial park. (Courtesy Upper Merion Township Public Library.)

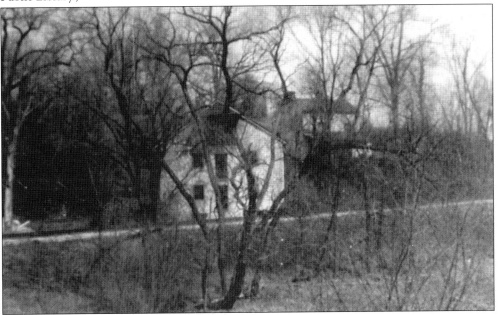

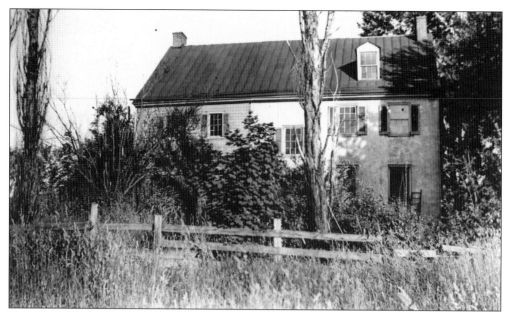

This house, located on King of Prussia Road, has gone by many names over the years. The first recorded deed for the land is to Thomas Rees, of Reesville (King of Prussia) in 1714, from William Penn. Although the land was deeded at that time, there may not have been a house there until sometime thereafter. The original house was a two story structure, probably dating from 1725 to 1750. The photograph (above) was taken in 1939, prior to its being purchased and completely restored. The photograph (below) was taken in 1970, and the old springhouse can be seen in the foreground.

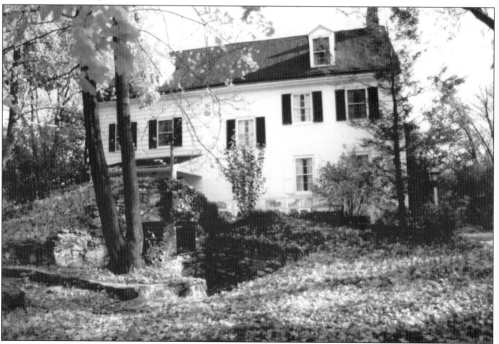

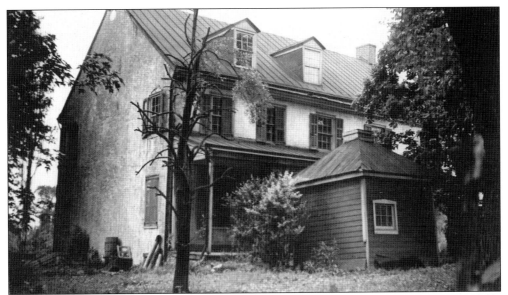

One of the most notable owners of the house was John Brooke, who ran the King of Prussia Marble Quarry in the mid-1800s. King of Prussia Marble adorned the home, which by now already had its high-ceiling addition, and served as a showplace for the opulent new building material. King of Prussia Marble can be found throughout the northeast. It signaled a change from wood to stone as the building material of choice. The Courthouse in Norristown, Fort Mifflin in New Jersey, and even the Senate Reception Hall in Washington, D.C., are made from King of Prussia Marble. The above photograph was taken in 1939 and shows the front of the house, which once had a covered porch. The photograph below was taken in 2000, as work began on yet another restoration of this great home. Sadly, the present owners plan to demolish the home if funds are not forthcoming to purchase it. The author is hopeful that it might be spared, as it is an architectural gem.

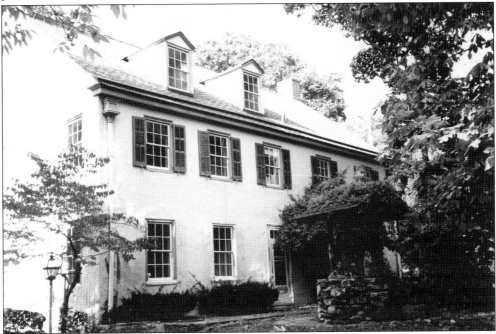

ACKNOWLEDGMENTS

When thanking those who assisted in bringing this project to life, one must first round up the usual suspects: thanks to my wife Diane, my mother Joan, and my sister Patty, for their ongoing support throughout this project. Thanks to Denise Long from the Upper Merion Township Public Library for allowing me access to its archives, and to the Township employees, David Broida, Ed Higgins, Don Herbert, Eileen Brennan Rodrique, and friends who made sure I had a place to work and lots to do. Thanks to my friends at the Senior Center: Doris Freeman, Emma Carson, Mary Raichle, former Township Supervisor Robert Clifton, and the countless others who dug through their attics and basements to come up with such wonderful photographs and background information. Without your help, this book would still be a dream. Thanks also to the Greater Valley Forge Chamber of Commerce, and the King of Prussia Historical Society, both under the watchful eye of Al Paschall. Thank you for your constant encouragement. Special thanks to Ed Dybicz, for taking me under his wing and for teaching me that facts are everything when documenting the past. Special thanks also to Frank Luther, for consenting to write the forward to this book and for keeping me focused throughout its planning. Very special thanks to Vincent Martino Jr., author of *Phoenixville* in the Images of America series and *Phoenixville* in the Then & Now series, for getting me started and making the time to teach me all about scanning photographs and layout. Finally, very special thanks to my grandmother Lucressa H. Morrison, for her undying patience and for hammering local history into my head, even when I wasn't listening very well.